Ms. Baross goes to Cuba!

Written and illustrated by
Jan Baross

Dedicated to my traveling parents

MPolo Press

Portland, Oregon

Text, cover and interior artwork copyright© 2016 by Jan Baross. All rights reserved.

No part of this book may be reproduced in any manner and without permission from the author and publisher.

Cover drawing: Jan Baross
Cover and interior design: TJ Rockett and Callie Jones
Edited by: Douglas Spangler
Aysha Griffin—www.InhabitYourDreams.com

MPolo Press: Portland, Oregon.
Publishers of award winning books

ISBN #978-1537576626
First edition

Other works by Jan Baross
Fiction:
"Jose Builds a Woman"
 First place for fiction, National Kay Snow Award, and Walden Fellowship.

Non-Fiction: Travel Series:
"Ms. Baross Goes to Paris"
"Ms. Baross Goes to Mexico: San Miguel de Allende"
"Ms. Baross Goes to Cuba"

Coloring book:
 "Cuba Coloring Book"
 "Mexico Coloring Book"

Photographic Books:
 "Portland in Bed on Sunday Morning"
 "China 1966"

Available at Amazon and Kindle

Website: janbaross.com
Book Clubs contact: bmi@easystreet.net

DIARY OF A CUBAN ADVENTURE

"Travel is the best way to stay amazed"

My dream of Cuba began in 1957 when my parents said, "You can come with us to Cuba or you can go to camp and learn to ride a horse."

I chose the horse.

They described Cuba as a lush island of spectacular beauty, endless music, and wide open fun. My youthful imagination took it from there.

In 1959, I read about about Castro's revolution. Later, after living through the Cuban missile crisis, I was left with the conflicting impressions of beauty and annihilation. Now, fifty-eight years later, I'm going with a troupe of writers to clarify Cuba for myself.

-Jan Baross, 2016

WRITERS IN CUBA
overview of the trip

Leading our troupe of seven American writers is Aysha Griffin, a consultant, travel writer and old friend. She has arranged our cultural tour that includes meeting top Cuban authors.

For eight days we bus to different towns and hear the stories from men and women writers who have lived lives of unimaginable deprivation which began when the Soviet Union abandoned Cuba in the 90's.

"For a time, power outages could last up to sixteen hours, food consumption was cut back to one-fifth of their level and the average Cuban lost about twenty pounds. Although starvation was avoided, persistent hunger became a daily experience." (Cubahistory.org)

When the other writers go back to the U.S., I stay on to get a more intimate view of what it's like to live and survive in Castro's highly regulated and tightly controlled Cuba.

It turns out to be an eye-opening experience.

GETTING TO CUBA

I'm surprised the flight from Mexico City to Havana is just two hours on Interjet Airlines.

I'm clutching my Cuban visa that I purchased next to the Interjet ticket line. Officials will stamp the visa instead of my passport so I can return to the U.S. without a hassle.

As the plane lands, I wonder if I might be one of the last people to see "Old Havana," before the U.S. embargo is officially lifted by an Act of Congress and modernization takes over.

Retrieving my bags and getting through Cuban customs is a test of my American impatience.

When I'm finally expelled into the damp air, my first impression is one of drenching heat and unbreathable humidity. I feel like I've just inhaled a monsoon.

A shimmering silhouette waves in the distance. It's my friend Aysha who arrived earlier. She gracefully guides me to the currency exchange.

CURRENCY EXCHANGE
Havana

Standing in line at the airport currency exchange window (CADECA) is my first introduction to the exhausting complexity of Cuban life.

Cuba has two monetary systems:

The CUC-Cuban Convertible Peso-for business and tourists.

The CUP-Cuban Peso-for the Cuban people.

Twenty-four CUPs equals one CUC, so check your change. Cuban money is useless outside Cuba, and should be exchanged before leaving.

There is a 10% levy for converting U.S. currency.

Cuba's dual monetary system has proven unsustainable, forcing President Raul Castro in 2013 to announce that their old system would eventually be replaced by a new one.

Little has changed so far, but this seems to be the government's customary strategy: promising change, even loosening a modicum of control to deflate tensions while maintaining a tight hold on the country.

The next regime is apparently primed to follow this same paradigm.

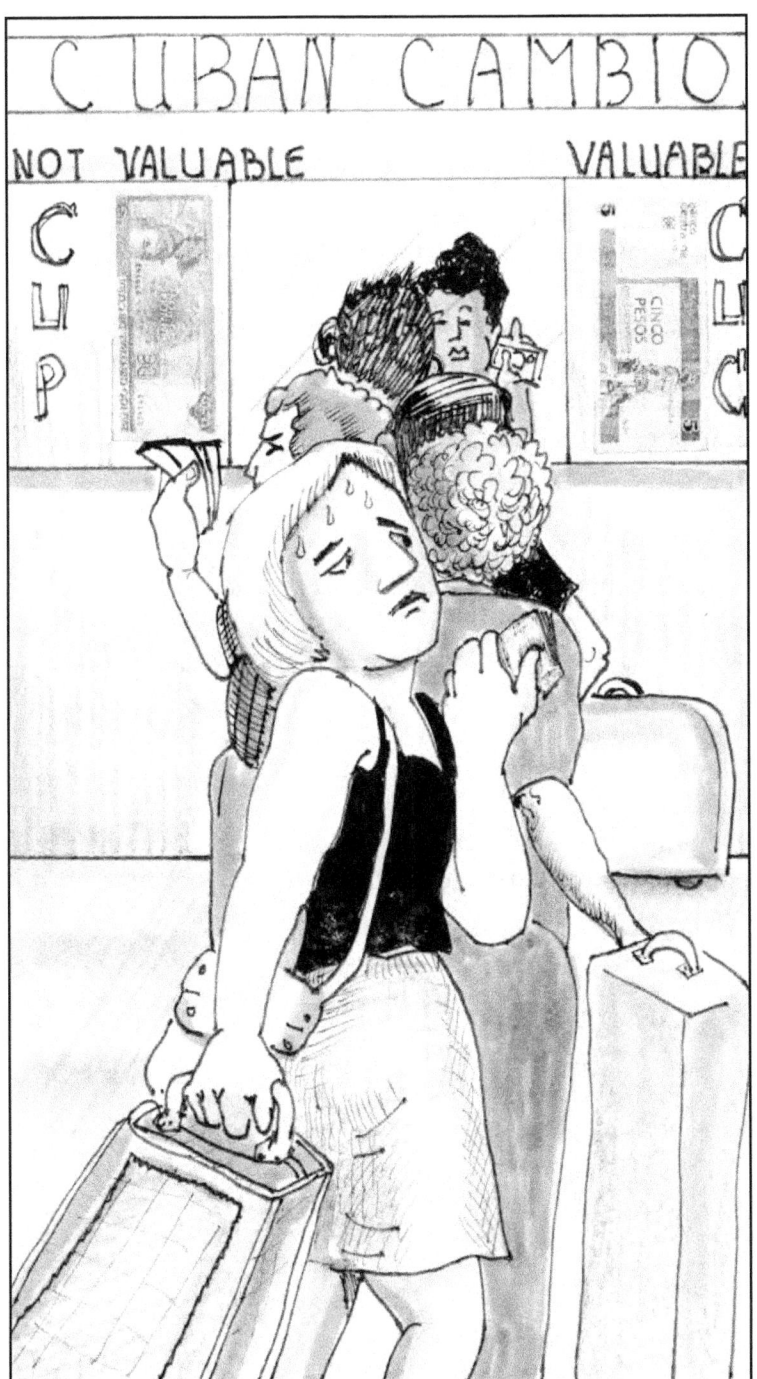

HOTEL PASEO HABANA
Calle 17 & A, Vedado, Havana

Our modest hotel is in the chic Vedado neighborhood. Vedado means *prohibited* because this area was once a dense forest through which pirates and attackers slipped in to invade early Cuban settlements.

My first adventure is being trapped in the elevator without power. When Cuban ingenuity frees me, I get to my assigned hotel room. The door sags like it's made of damp cardboard. My replacement room has a loud air conditioner and lizards on the ceiling, as a kind of transient calligraphy.

Our hotel's redeeming factor is access to WiFi. (pronounced Wee-Fee)

Responding to the pressure cooker demands of Cubans to enter the twenty-first century, President Raul allows WiFi access in a number of easily monitored locations around Cuba.

For an hour of filtered web time, I pay $3 to purchase a state-issued card from the hotel concierge or the corner black market.

Young Cubans who can't afford a card lean over their cell phones along the perimeter of the hotel and jockey for WiFi signals.

WIFI GRANDMA
Hotel Paseo Habana, Vedado, Havana

I join our group on the hotel's humid veranda where they're scarfing down free introductory mojitos. I take a sip and nearly choke when an elderly Cuban woman shrieks and clasps her hand to her heart. She stares into a cellphone and shouts,

"Mis nietos! Yo no lo puedo creer! Te amo!"
(*My grandchildren! I can't believe it! I love you!*)

Apparently Grandma is viewing her grandchildren in the United States for the first time. When they answer on the speakerphone, their little voices yell,

"Te amo, abuela!"
(*I love you, grandma!*)

The old woman bursts into tears and then delighted laughter.

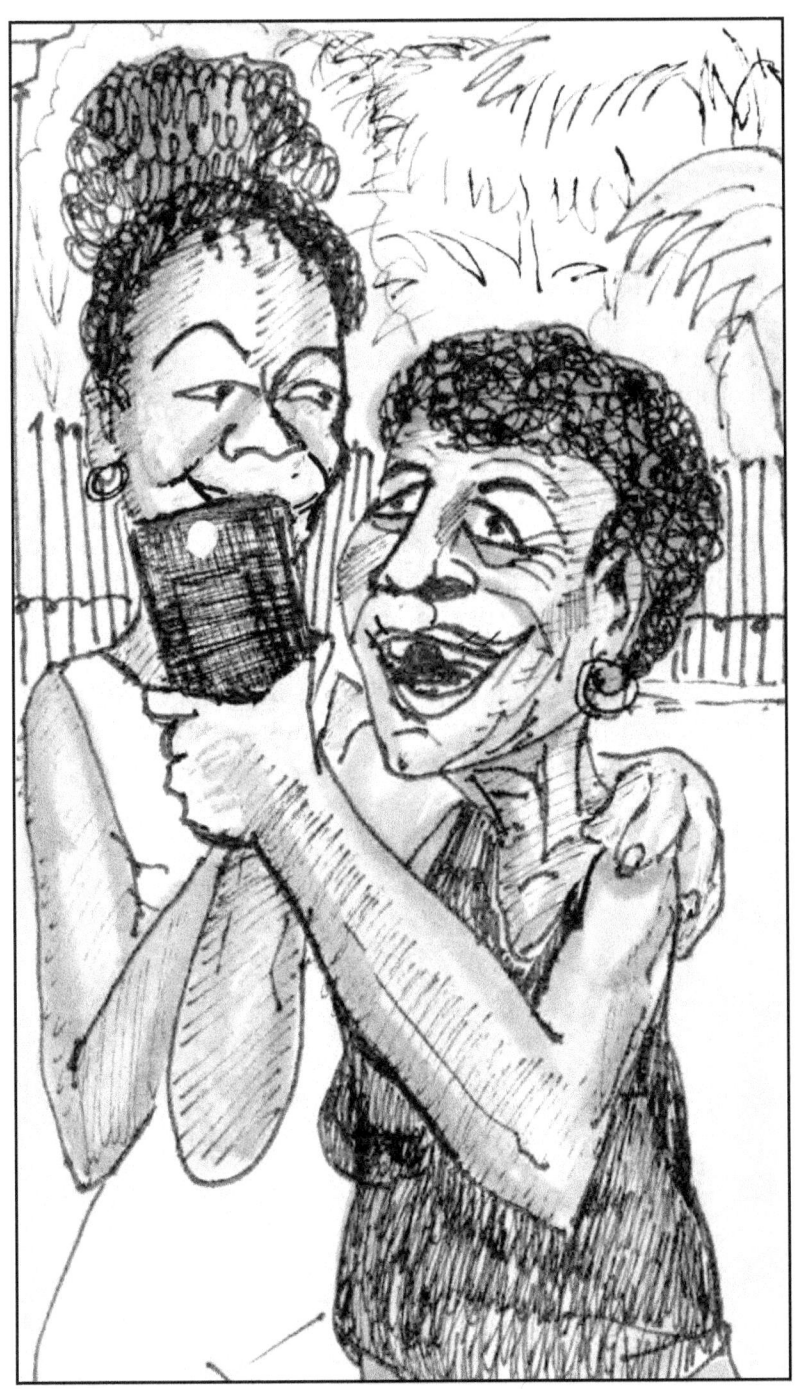

A WALK IN THE VEDADO NEIGHBORHOOD
Havana

Since there's time for an early evening stroll before dinner I'm off to explore the "hood."

Banyan trees spread their roots under cement sidewalks creating a slanted obstacle course. I note a chic coffee shop. Next to that is a poorly stocked outdoor market, next to a beautifully restored mansion, next to a disintegrating baroque villa. Architectural beauty sighing into ruin along the street, with Cubans sitting jobless, but congenial, on their mildewed porches.

These homes of once wealthy Cubans were given to the citizens so that everyone became instantly equal. But few provisions were made for the long haul and as many as twenty families now live in one neglected mansion. I can't begin to imagine the plumbing and water problems.

Glancing up, I'm surprised to see the upper half of a mannequin nailed to the wall of a third story home. The arms are outstretched as though escaping through the decaying plaster.

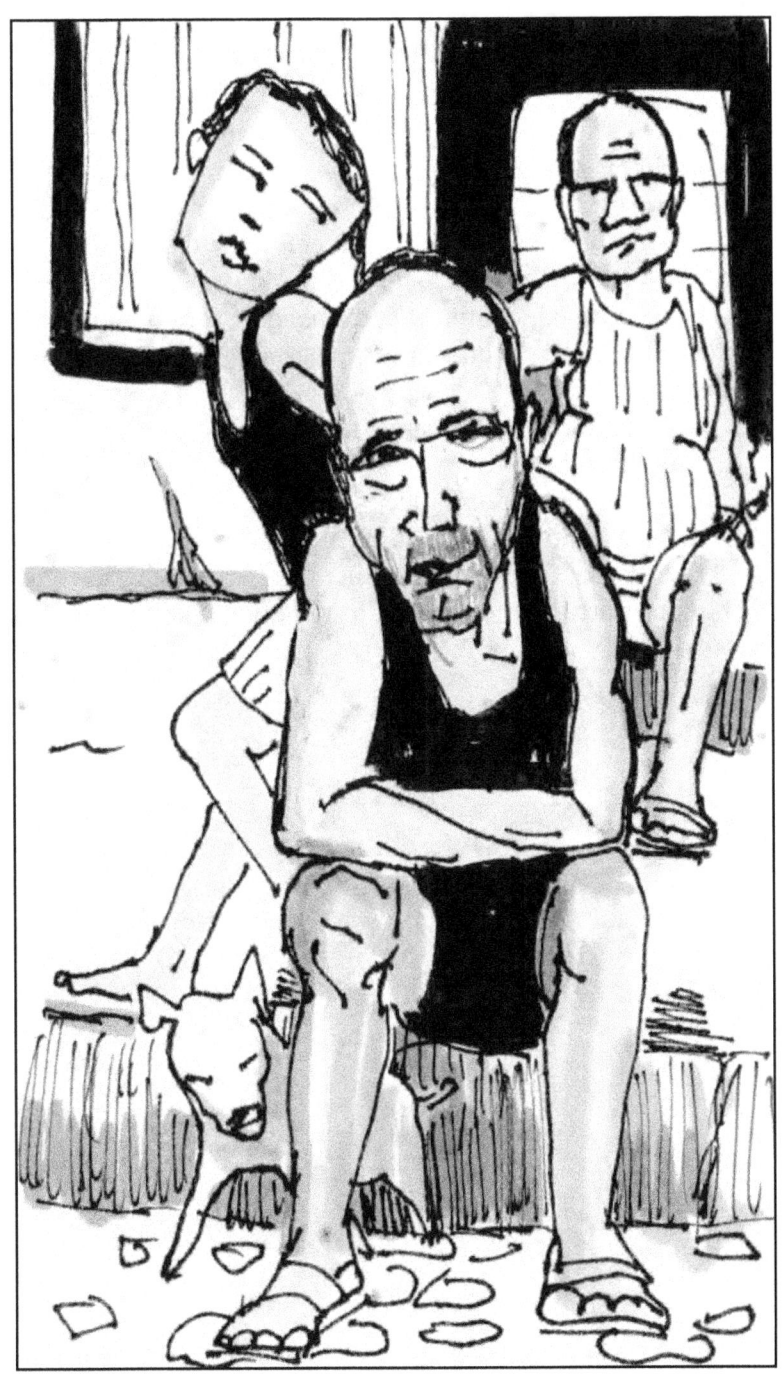

STROLLING WITH CUBANS
Havana

The early evening air is soft and warm as I amble past my neighbors.

I love how Cuban men and women carry themselves, as if they know how to have a good time, or have recently had one. Their loud, animated exchanges remind me of Italians. Both talk exuberantly in the parallel language of hands.

In passing, the Cubans smile and say,

"Buenas tardes."

Their "good evening" doesn't sound like the Mexican Spanish that I am used to hearing.

"Buenas tardes," becomes "Buen tar," as though someone is holding onto their tongues. It has a softening effect on the words.

SAFETY IN CUBA
Havana

As the sky deepens to a dark purple. I wonder how smart it is to continue wandering unfamiliar Cuban streets without a bodyguard.

Actually, the only "gang" of young men I encounter are boisterously congealed around an outdoor barber.

Later I learn that Cuba has very little violent crime. Any infraction is severely and quickly dealt with. There are occasional thefts, but certainly no drive-by shootings. It's illegal to own a gun and, besides, who can afford one?

As one Cuban writer joked, "One thing can be said for a dictatorship regarding crime; no one gets to abuse their fellow man like the regime."

Despite feeling fairly safe in Cuba, I've been so fear programmed from living in the U.S. and Mexico that going out alone at night just doesn't feel comfortable.

El PENTHOUSE DE CAFÉ
Calle 17 & K, Vedado, Havana

For our first dinner in Cuba we're going to a chic restaurant called The Penthouse. A small elevator struggles up to the third floor *paladar*, a privately-owned, newly state-sanctioned restaurant.

The Penthouse veranda gives us a breathtaking view of lighted Havana below as we sip the ubiquitous mojitos and daiquiris.

I order white fish in a tomato-based sauce that includes green olives. The house salad introduces me to the sweetest avocados I've ever tasted. It's the kind of luxury cuisine I hadn't expected on our writers' tour.

Sitting and chatting with me across the table, are my two literary pals from home. We realize we haven't taken the time to enjoy each other's company like this for months. Something must be amiss in our lives if we have to go all the way to Cuba to catch up.

CENTRO DULCE MARIA LOYNAZ
Calle 19, #502, Vedado, Havana

This is our big day in Havana. Top Cuban writers are waiting as we enter the restored, marble-floored mansion of Centro Cultural Dulce Maria Loynaz. Senora Loynaz is one of Cuba's most beloved poets.

What draws my interest is a handsome man seated across the overly air-conditioned room. Dark-haired Alberto Edel Morales Fuentes is introduced as an award-winning poet, novelist, editor and founding director of the Dulce Maria Dolce Center. He turns out to be extremely shy and, for some reason, hides his teeth as he reads us a few of his poems.

A simultaneous and brilliant translation is provided by Susana Haug, a senior professor of Latin American Literature at the University of Havana.

Next up is the energetic Marilyn Bobes; poet, journalist and novelist. She gives us a wide smile and shares a funny off-color story that makes Susana blush as she translates.

Alberto Naranjo, a tall, charismatic Afro–Cuban with an ironic sense of humor shares his short story, "Peas in a Pod", about brotherly sacrifice, that has us all close to tears.

The exchange continues and I read from my novel that has an appropriately Latin setting, "Jose Builds a Woman."

MEDITERRAENEO CAFE
Calle 13 #406, Vedado, Havana

During lunch with our new Cuban friends, we learn how isolated they are from information. With limited access to the internet, they don't know what's involved in publishing. We do our best to enlighten them.

What impresses me most about these writers is their incredible resilience. No matter what constraints have been imposed on them, they just keep writing.

I joke to one of the Cubans about having another revolution.

He says, "The people are submissive to a system that they've lived under all their lives. The blockade is within as well as without. The best we can do is survive or leave."

What a loss for Cuba or any country that tries to shackle its artists.

UNEAC (*National Union of Writers and Artists of Cuba*)
Calle 17, between G & H, Vedado, Havana

When the state preserves its heritage, it does an excellent job. The lush garden surrounding the UNEAC mansion is an opulent meet-up haven for writers and artists.

We join our Cuban friends and order the popular Cristal. It's a pale lager made by Cerveceria Bucanero, a government joint venture with Anheuser Busch.

A rhumba band sets up on the veranda and begins to play. Our friends give us a little background on Cuban rhumba.

The music grew out of the oppression of enslaved Africans in Cuba. Even after slavery was abolished in 1886, the music and dance continued to evolve into today's passionate rap with a social and racial identity.

Tonight's performers range from old timers in their eighties to energetic teens, each generation updating their collective rage. The main rhumba rapper reminds me of a young Julian Bond, the handsome black 60's civil rights activist.

DANCING AT UNEAC
Havana

The band plays a captivating rhythm.

Everyone moves, rocks and sways.

A man with coffee-colored skin and green eyes is sitting at the next table surrounded by three black women with huge smiles.

He lunges over and asks me to dance.

I've never danced rhumba.

He takes me in his arms and begins to move.

The beat is so deeply rooted in his body it awakens the same rhythm in me.

Our legs move weightlessly like soft light between shuddering ferns.

If this is dancing, I haven't lived.

LOS NARANJOS RESTAURANT
Calle 17&A #715, Vedado, Havana

The evening air is so hot my fellow writers and I take a stroll in search of an elusive Havana breeze.

As we cross the street, a smiling man introduces himself as Alex and waves us into his mansion. It turns out to be a restaurant with a colorful bar.

The mansion was once Alex's family home. They had to abandon it during the revolution. He returned recently from the U.S. with enough backing to open Los Naranjos Restaurant.

But the major problem was how to bring patrons in.

Just as he thought he would have to close his business, an American tourist wandered in and was so impressed that he posted a rave review.

The restaurant has since become a dining destination.

After Alex serves us lobster and an amazing salad, he says, "When you Americans come to my restaurant, you are family."

CARS IN CUBA

The emblematic image of Cuba is the shiny, restored 1950's convertibles with a bright coat of paint and huge nautical fins. My parents had a Caddy like that in the 50s when success was excess. These exquisitely restored cars offer luxury transport with the added romance of sun and wind in your hair.

The cheaper ride around Havana is the unrestored community taxi called "almendrones" *("almonds" for almond shaped)*. With the inner door panel rotted away, I'm fascinated to see the structure of pulleys and wires that does the simple act of rolling the window up and down.

Unfortunately, there seems to be no environmental regulations and there are few replacement parts for anything in Cuba.

As a result by late afternoon there is a blue haze over Havana in spite of the sea breeze. It's no wonder many Cubans suffer from asthma.

CUBA LIBRO BOOKSTORE
between Calle 24 & Calle19, Vedado, Havana

Cuba Libro is the first English language bookstore, café and literary salon in Cuba.

"I know how hard it is to get English-language sources here," says owner, and former New Yorker, Conner Gorry.

Gorry moved to Cuba in 2002 and has broadened her goals from an English language center to include health and education for the poorest Cubans, some of whom are her neighbors.

As Gorry shares her insights about Cuba with us, a young man comes in to get free condoms piled in a basket near the door.

A gang of small children move past us to the books on her makeshift shelves.

Before we climb back onto the bus, we leave donations and our books to support her ambitious projects. (Conner's Blog: "Here is Havana")

MERCADO AGROPECURARIO
Calle 19 & B, Vedado, Havana

Ah, Havana. The morning sky is blue and the day is not yet as oppressively hot, humid and debilitating as it's going to get. Our group steps lightly, as we've learned to do, over the root-cracked sidewalks to our destination at the market.

Cubans are queued up along the sidewalk with their monthly ration books, waiting patiently to enter a huge state-run warehouse called the peso store. They'll exchange their coupons for poor quality flour, rice, sugar, cheap rum, and essentials like soap if any are left on the nearly bare shelves. Toothpaste seems especially hard to come by.

Cuban bread is made at the government-run bakery. It's tasteless and crumbly because the workers sell the butter and eggs on the black market while substituting who-knows-what in the flour.

Most people's survival depends on some kind of hustle like this, making every legal or illegal opportunity count for cash.

Though some profit at the expense of others, I admire their ingenuity and priorities. Who doesn't need to feed their family?

PIZARRA de DISTRIBUCION				
PRODUCTOS NORMADOS				
FECHA	PRODUCTOS C.R.	PRECIO	por PERSONA	
7/3/90	ARROZ NOR	0.25	5	
2/10/2	FRIJOL NEGRO	0.20	10	
3/04/4	AZUCAR REF	0.15	3	
4/04/4	CAFE	4.00	2	

AGRO MERCADO
19 & B, Vedado, Havana

To the right of the peso warehouse, we enter a covered market with fresh vegetables and meat. Our translator Susana says that people who shop here usually have relatives sending money from the U.S. or have prospered on the black market.

Outside we meet Susana's mother, Angela, who lives nearby. She invites our group to her house for dinner.

We accept, but only if we pay for the food.

Hopefully, all the elusive provisions she'll need for the large meal will be in this one market.

Like every working Cuban, Susana, her mother and her father, both company executives, receive $25 a month as wages from the government along with one coupon ration book each.

It makes no economic sense to me that all Cubans whether street cleaner or doctor, receive the same pay. Even more amazing is the pride people take in their work. They don't slack off just because their wages are unlivable.

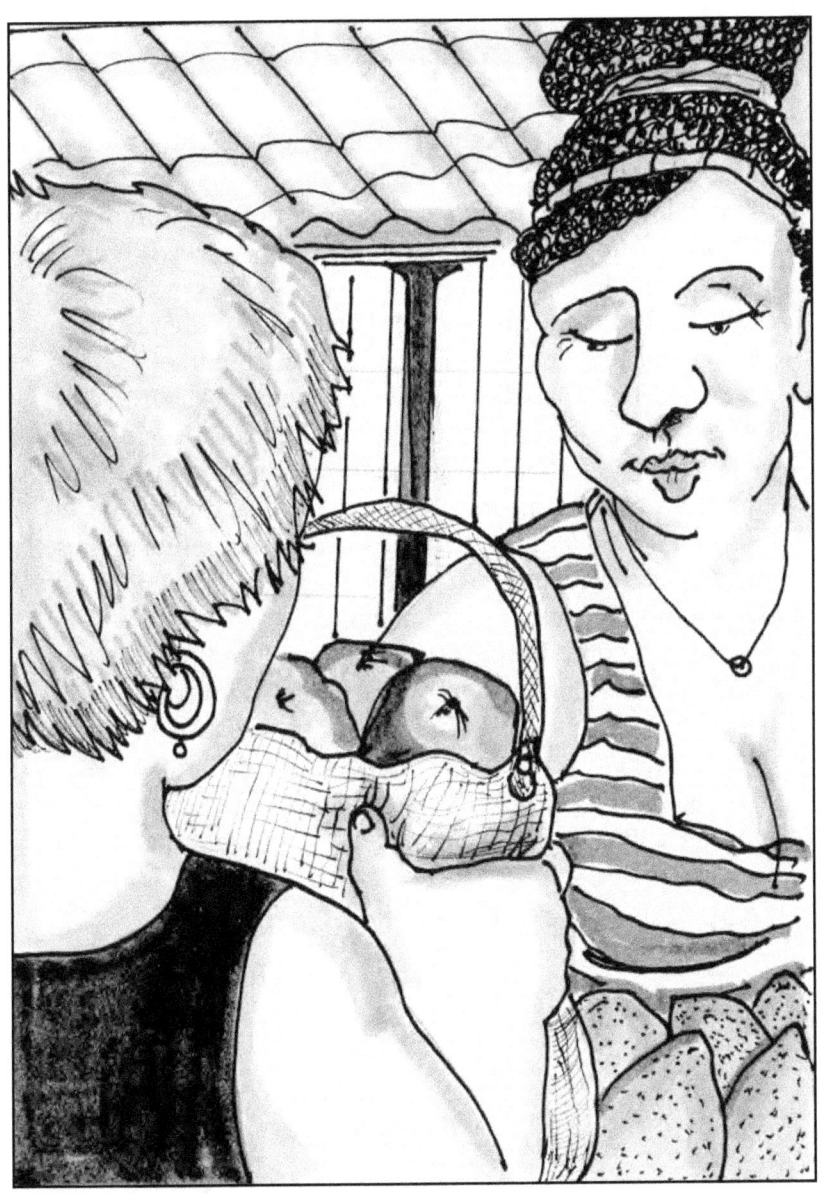

A LITTLE HISTORY NEVER HURTS

After the successful Cuban revolution in 1959, President Fidel Castro educated the populace out of illiteracy in only 18 months, with the help of thousands of literate volunteers. But, as a young lawyer he had had no experience running a country.

When President Eisenhower began the U.S. embargo in 1961, Castro accepted Krushchev's offered of trade and aid.

The economy worked under Communism because Soviet rubles filled in the cracks. But when the U.S.S.R. collapsed in 1989, Cuba's economy ground to a halt. In spite of free education and medical care, the people suffered in this "Special Period in the time of peace" as Fidel refers to those years. And they continue to suffer shortages. When I tried to buy aspirin, the pharmacies had none.

Fidel is gone. Raul Castro has announced he will soon retire. The National Assembly of People's Power will select the next president who will continue to have power over every branch of government including the Armed Forces.

Progress toward prosperity for the average Cuban is slow or non-existent.

THE BIG CUBAN HOME COOKED DINNER
Vedado, Havana

After touring Havana all day, we starving writers are looking forward to a relaxing home-cooked meal.

The evening begins with a muggy sunset and a short walk to Angela's small apartment.

We are welcomed with hugs from Angela, Susana, her sister and each of their husbands.

The entire family has been preparing all week for our arrival. Only the black kitten seems slightly freaked by all of us wedging ourselves around an angled dinner table that barely fits in the front room.

The meal is luxurious, especially by Cuban standards: chicken, pork, rice, vegetables, salad, fruit, ice cream, white cake, flan, pastries and booze.

We're all overwhelmed by their generosity, knowing what a huge undertaking this has been for the family.

It's a wonderful sendoff for our last night in Havana.
In the morning we'll be boarding a bus for Cienfuegos.

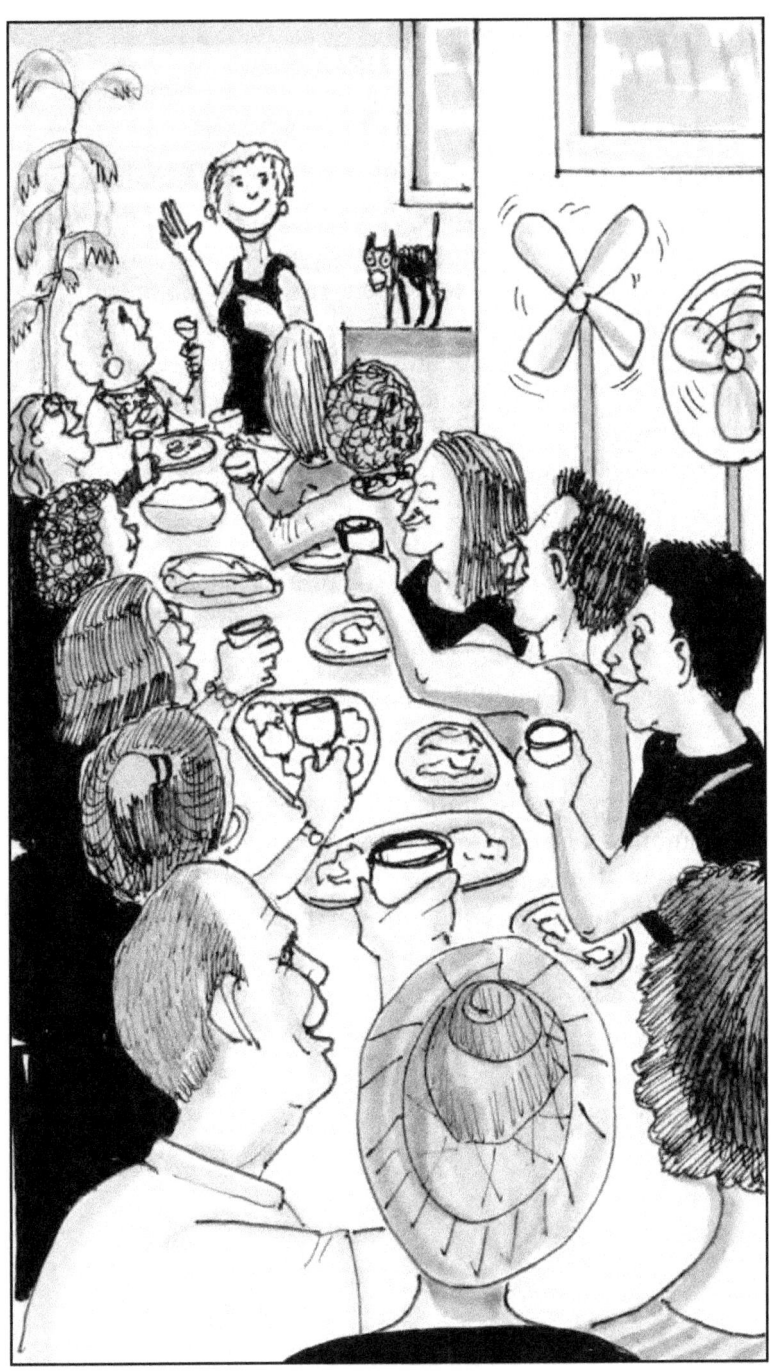

CIENFUEGOS
Cuba

Candido, our driver, kisses our hands as we climb into the air-conditioned bus. He's short, handsome and has an exhuberant personality. I'd never guess he was once a trained Navy SEAL equivalent in the Cuban military. His position probably got him this plum job. All he has to do is drive, flirt, park and in return he has access to tourist tips which pay much more than he could ever make as an officer.

It takes four hours to reach the southern coast of Cuba. The countryside is green and lush, though I had expected to see more farms.

Candido slows as we drive into the sparkling seaside town of Cienfuegos. It's the capital of the province, founded by the French in 1899.

The colorful buildings have a luminous delicacy and, after polluted Havana, this "Pearl of the South" is pure heaven.

We gorge on seafood at outdoor La Casa Verde Restaurant situated by an expansive blue bay.

A cool breeze flows past our table and music from the guitar trio lulls us with a gentle rhythm.

UNEAC
Cienfuegos, Cuba

The sky turns stormy as we enter José Martí Plaza, a beautiful tree-lined square with colorful Rococo buildings.

Before we meet the local authors, we stop off at Teatro Tomás Terry, built in 1887. It looks like a movie set for "Phantom of the Opera," creaky, majestic, romantic and embellished by Carrara marble and ceiling frescoes.

I wonder what the acoustics were like when Caruso and other greats sang here.

An afternoon rain streaks across the plaza as we run to a covered patio at the local UNEAC building.

We wait for the local authors on foldout chairs in a circle and try to ignore the odd sculpture of a naked woman emerging from the stucco wall.

Damp, young and brilliant, the Cuban writers arrive without umbrellas. Some have traveled hours on buses from their small villages to meet with us. We listen to the power of their words translated by Susana. Some work is simple, some naïve, others are complex, but all of it has a deep authenticity.

I'm impressed with this young group that has courageously maintained a writing life while living and struggling in the impoverished countryside. It seems talent takes root anywhere. It can't help itself.

PALACIO DE VALLE
Cienfuego, Cuba

After fond farewells to the young writers, Candido drives us though the rain-soaked sunset to the tip of the Punta Gorda peninsula. Our Hotel Jagua crouches in a jungle setting with small air-conditioned rooms and a large swimming pool.

Across the parking lot is the magnificent castle, Palacio de Valle. Built in 1913 as a wedding gift, it's an opulent mix of Venetian, Gothic and Neo-Moorish architecture with sphinxes guarding the entrance.

Once an impressive Batista casino, the palace is now an eclectic restaurant. On the red and orange rooftop, is a bar with small tables filled with sunset drinkers.

The smiling Cuban band plays "Guantanamera" and beyond the harem-style architecture is a great slide of turquoise sea under a soft golden horizon.

I pull up a chair and order a mojito. When I open my sketchbook, the white pages glow golden from the tinted clouds above.

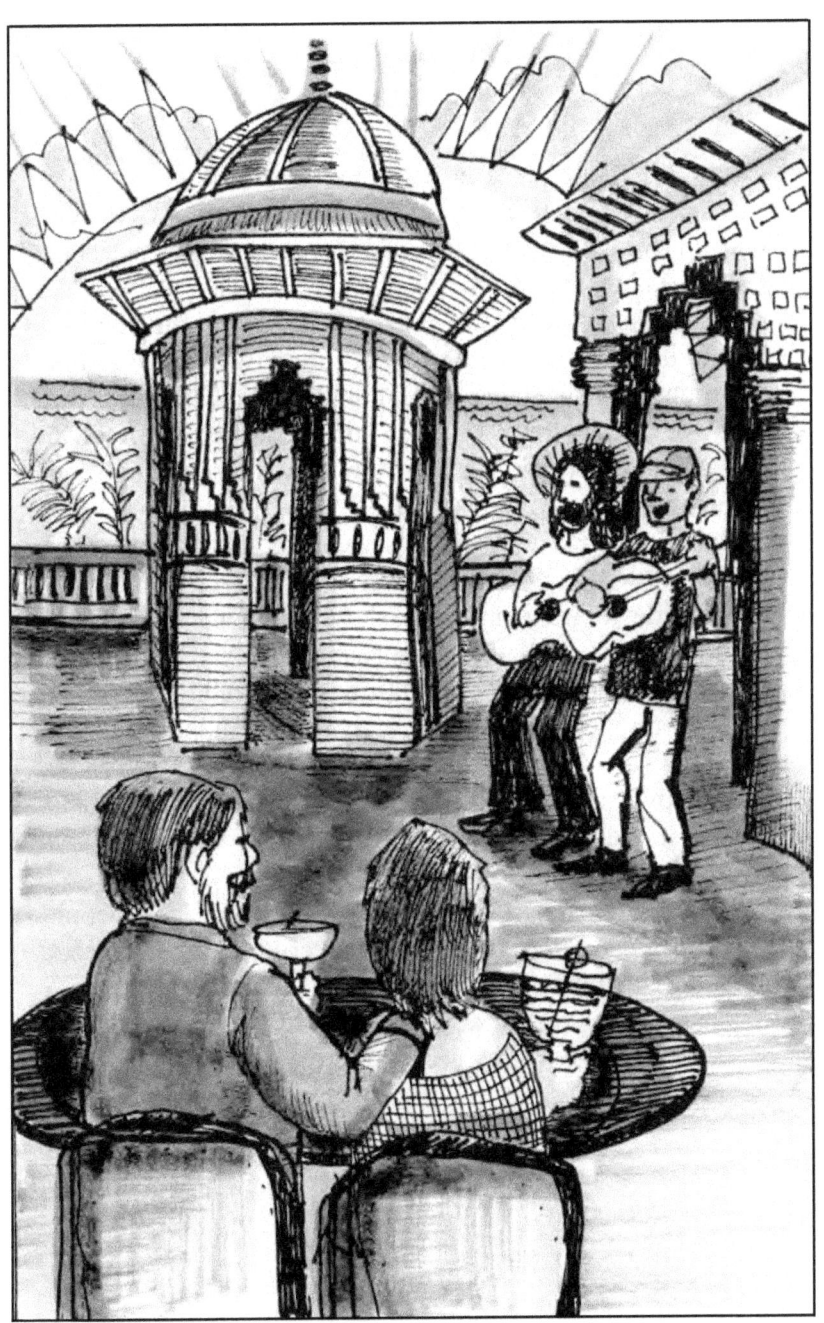

TRINIDAD
Cuba

Candido drives us past green fields and forests toward the province of Sancti Spiritus. We arrive in the UNESCO World Heritage town of Trinidad. No author meet-ups here, just an aesthetic infusion.

We're assigned *casas particulares*, the equivalent of Airbnb units. Private home owners are now allowed to rent out rooms as one more essential link for Cubans to the lucrative tourism trade. I'm lucky that my room is new, clean and air conditioned because a few of the writers get older accommodations without AC.

Some of the group spend the afternoon at Playa Ancon beach.

I decide to wander in the showy colonial splendor of Trinidad central, called the "museum of Cuba."

Cobblestone streets wind past pastel colored restaurants, small stores, ice cream parlors, markets, outdoor bars and vendors.

The town square is like an amphitheater awash in music. Cubans move to the band's beat and one of the writers gets up and dances by herself, brave and sexy.

Later, by chance, I find a bleak library that Kafka could have designed. Rows of yellowed crumbling hardbacks, stained linoleum floors and water marked walls.

That evening on the walk home, I buy a colorful painting of a village scene from a very attractive young man.

SANTA CLARA
Cuba

After a big breakfast, we pack up and drive through the central region of Cuba to Villa Santa Clara, the capital city of the province.

Ricardo Riveron, a famous critic and vice president of the Santa Clara UNEAC, takes us to a well-known bookstore, "La Piedra Lunar" at Calle Luis Estévez 217.

The store's owner, Lorenzo Lunar, is one of Cuba's finest detective novelists.

We begin by reading our works aloud to each other in the tiny, sweltering bookstore. Overcome by the heat, we adjourn to the Hotel Santa Rosalia for a buffet lunch.

I sit next to rake-thin Geovannys Manso, a prize-winning poet who eats almost nothing of the overcooked food. He had been training as a doctor, but dropped out to care for an autistic son, about whom he shares a powerful poem.

After lunch we continue our conversation in the private room of an art gallery, leaving behind the government informants who meet us at each destination, appearing in the guise of helpful tour guides.

ERNESTO "CHE" GUEVARA MEMORIAL
Santa Clara, Cuba

On a hill above the town of Santa Clara, stands an enormous statue of Che Guevara, an Argentine Marxist revolutionary guerilla, physician and a fellow author.

In 1959, Che triumphed over Batista's army on this site and won the decisive battle of the revolution.

A plaque reads, "Hasta la Victoria Siempre," (*Always Strive for Victory.*

It's interesting to me that Che had time to be such a prolific author, churning out many articles as well as his memoir, "The Motorcycle Diaries" which was made into a bio-pic.

Fidel chose the handsome, charismatic Argentinian as the poster boy for the revolution. Which is probably why, along with his triumphant Battle of Santa Clara, Che seems to be more of a hero to the Cuban people than the Castro brothers.

Che was killed in 1967 by the CIA when he led an armed uprising in Bolivia.

His remains are housed in the extensive mausoleum behind his statue on the hill.

In classrooms across Cuba school children salute his memory every day by chanting,

"We will be like Che!"

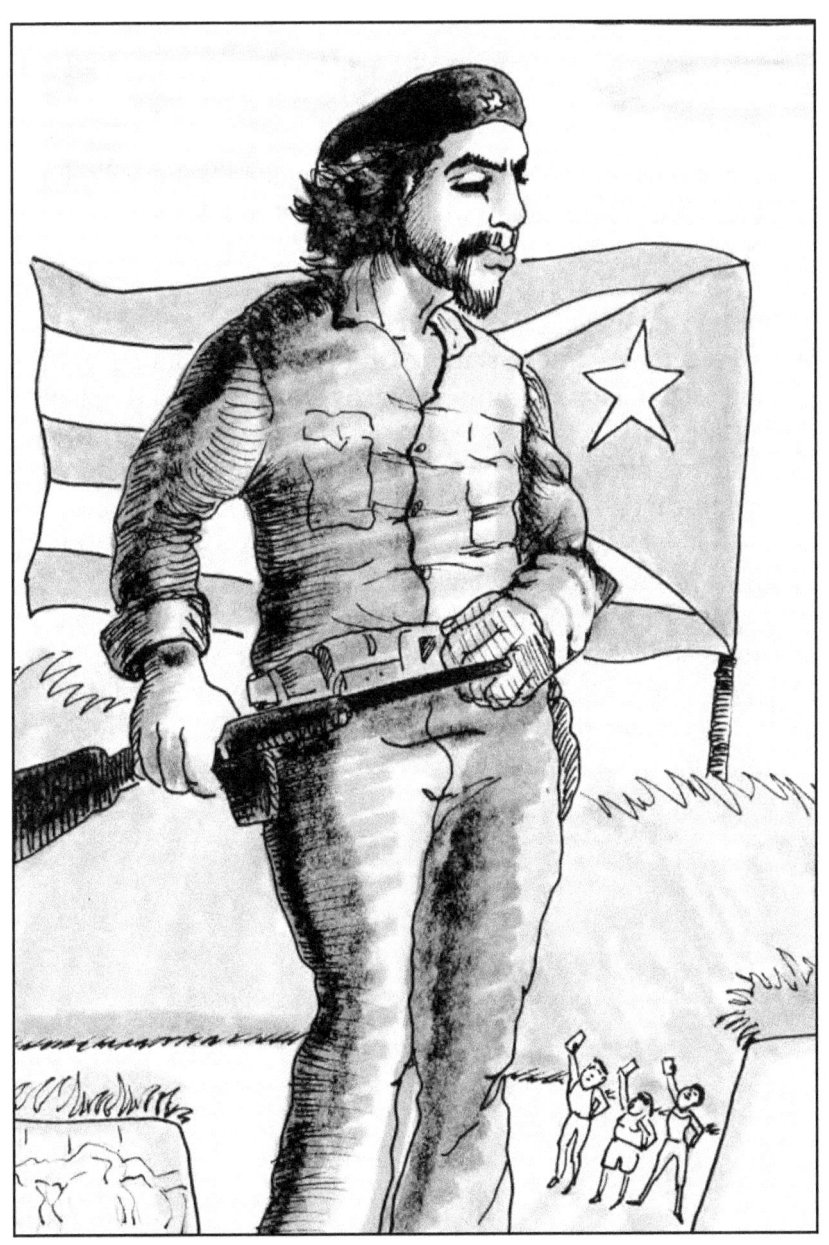

VILLA GRANJITA
Santa Clara, Cuba

On the outskirts of Santa Clara is the unique Hotel Villa La Granjita, a combination of organic farm and solar-paneled "eco" hotel.

It was built specifically for the Cuban people but it has become a popular stay for officially sanctioned tours.

Free range chickens peck around the swimming pool rendering themselves inorganic by eating bathers' fallen Cheetos.

In the surrounding pastures, horses graze serenely in magnificent poses as though begging to be photographed.

Cultivated rows of organic vegetables grow beside our individual red circular bungalows.

Along the cement pathways are metal sculptures, and across a lush ravine, the hotel restaurant serves freshly grown fare.

It's an incredibly peaceful sanctuary and reminds me of my home in Oregon.

MATANZAS
Cuba

Our last brief stop-over is in the small riverside town of Matanzas, known for its poets and rich literary history.

At Editoriales Matanzas, a publishing house, we're introduced to Yanira Marimón, an award winning poet. She fills us in on the local writers and their works.

After lunch at the main hotel on the plaza, we visit Ediciones Vigía, a small independent publishing collective specializing in handmade books.

A hard rain bombards the bus as we head back to Havana and the magnificent Hotel Nacional. For the entire trip, I've been anticipating entering those same legendary portals as my parents entered fifty-eight years ago. And now that time in history is only an hour away.

I sit back in my seat and remember an old photograph of my parents' trip, the youthful couple, glasses raised over a white tablecloth in the Hotel Nacional dining room.

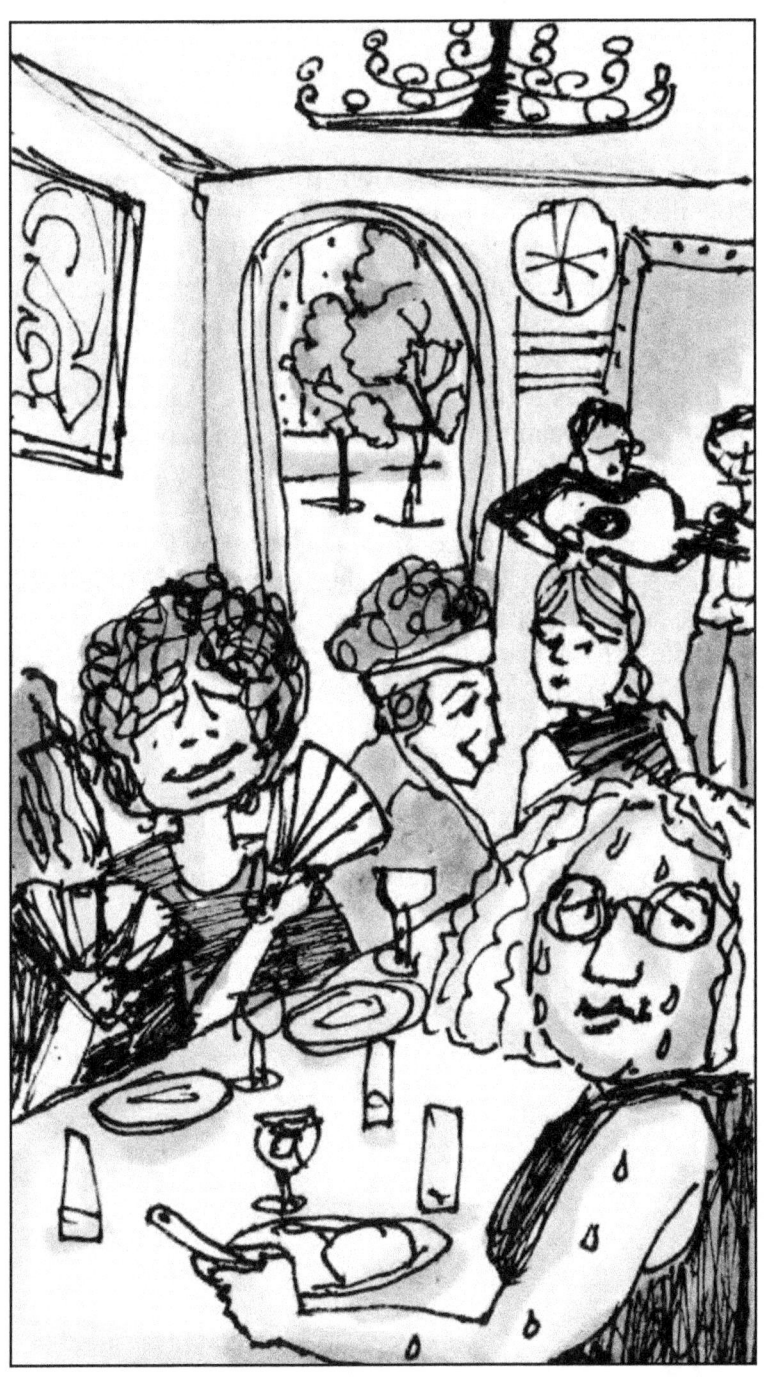

HOTEL NACIONAL
Calle 23 &12, Vedado, Havana

From my parents' description in 1957, the Nacional sounded like the stuff of legends. And it was for them.

In reality, it's a tall white building built eighty years ago and has a gigantic marble lobby that amplifies the echoing crowds. A grassy cliff behind the hotel overlooks the Malecon with a view of the seawall and the city.

In the famous hall-of-fame bar, are huge black and white photos of international glitterati who tanked up here in the 40s and 50s: Frank Sinatra, Churchill, Jean-Paul Sartre, Meyer Lanksy.

Lansky owned a piece of the Nacional and was one of the most powerful Jewish mobsters of his time. My Jewish family is jam-packed with doctors and accountants, but a gangster? Now that's thrilling.

For dinner, all the writers gather around a long table in the magnificent Nacional dining room. A pianist plays as we toast with daiquiris. This last meal together is going to be the highlight of the trip. The service is slow but, so what?

At the end of the dinner, our consensus gives the Nacional's bland cuisine a big thumbs down.

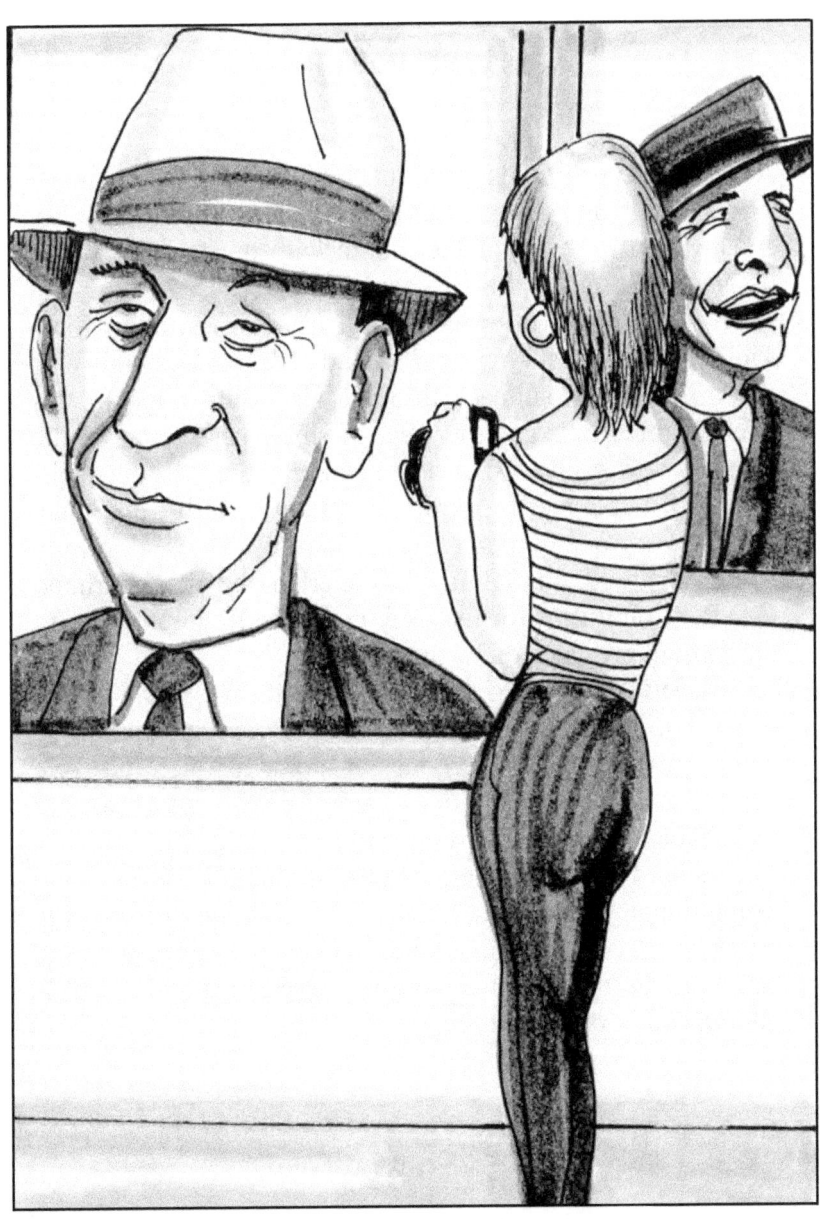

LIVING IN CUBA
Vedado, Havana

After our writer friends depart back to the U.S., Aysha and I taxi to a 1950s apartment complex in the Vedado. We're staying until the end of the month with the family of our translator, Susana, so its like coming home.

Aysha moves in upstairs and I am downstairs in Uncle Tio's apartment with my own private bedroom and bath.

As I roll my suitcase through Tio's tiny kitchen, I'm overwhelmed by a gagging heat. A single gas burner on the small stove is going full blast. Apparently, the subsidized gas is cheap, but matches are hard to come by. It's a Cuban thing to keep one burner going.

As required, the family has alerted the neighborhood C.D.R. (Committee for the Defense of the Revolution) as to the foreign presence of Aysha and me.

My new life in Cuba begins with a large breakfast in Tio's dining room and ends with a big dinner at night. Maria, the elderly maid, cleans my room the moment I step out. I've never been so overwhelmingly cared for with advice for my well-being, my asthma, my itinerary.

It's hard to comprehend that the six highly-educated and professionally employed adults in the family each bring home a salary of $25 a month. Yet they take care of the strangers in their midst with generosity beyond what is anticipated in my rental fee.

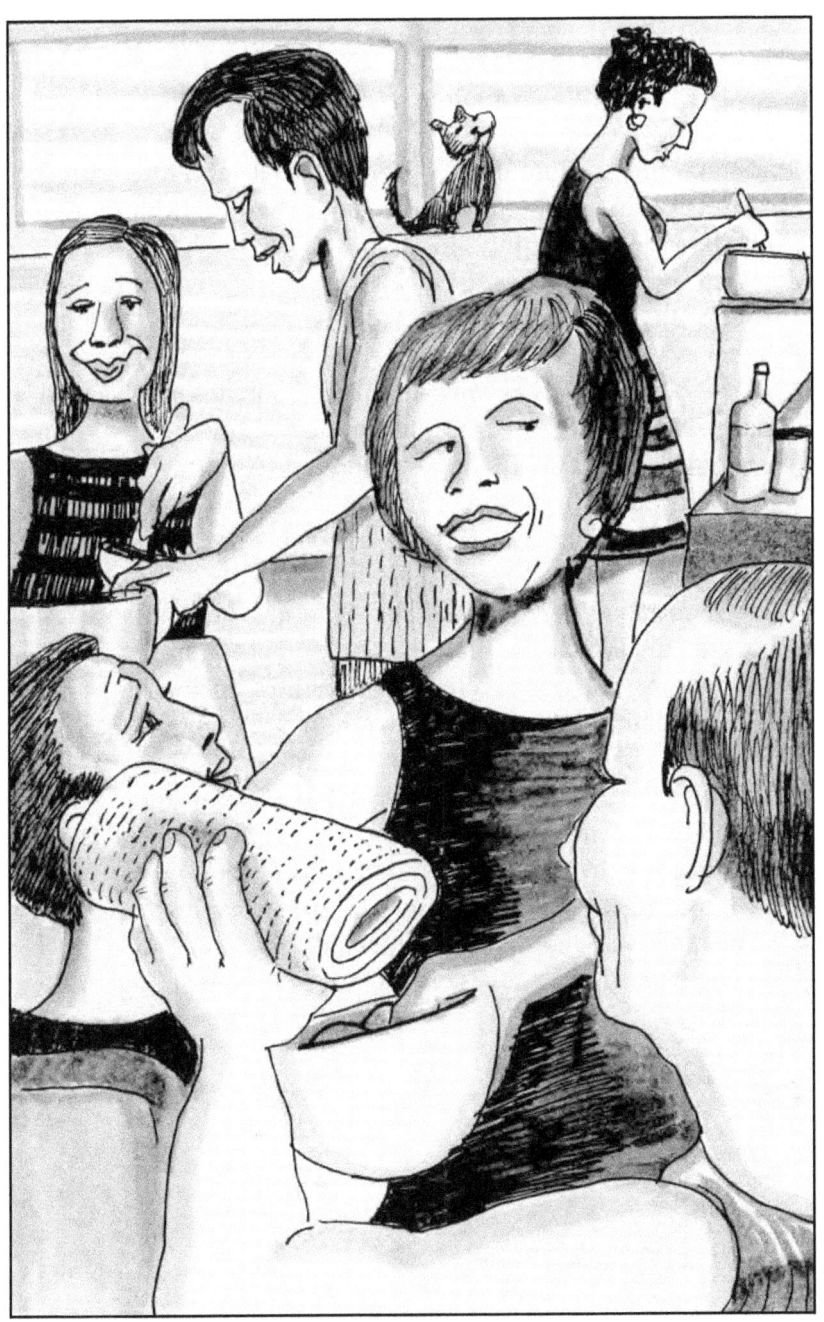

THE STORY OF UNCLE TIO
Vedado, Havana

My apartment roommate is Uncle Tio, a tall, shy, retired doctor. He loves baseball on TV and when I tell him I also like baseball, he confides his story.

Tio was a talented baseball player in his youth. An American scout wanted to take him to the U.S. but his father was in jail for refusing to become a Communist and so Tio remained in Havana to take care of his mother and sister. He dutifully set his sights on medical school.

Later, as a student, when he applied for a travel permit, he was accused of plotting to defect and the state sent him to do hard labor on a farm for the five years among hardened criminals.

When his father was released from jail, he got Tio back into medical school, but the state made him start all over again. Tio perservered and became a doctor.

Years later his wife, who gave him one son, went to the U.S. for medical reasons and never returned.

There is resignation in Tio, but I also see resilience and courage. To show my admiration, I give him what is so hard to come by in Cuba, my giant tube of toothpaste.

I ask if I can sketch him. He presents himself in a vulnerable way that I hadn't expected.

The Cuban heart never closes, not even to a stranger like me.

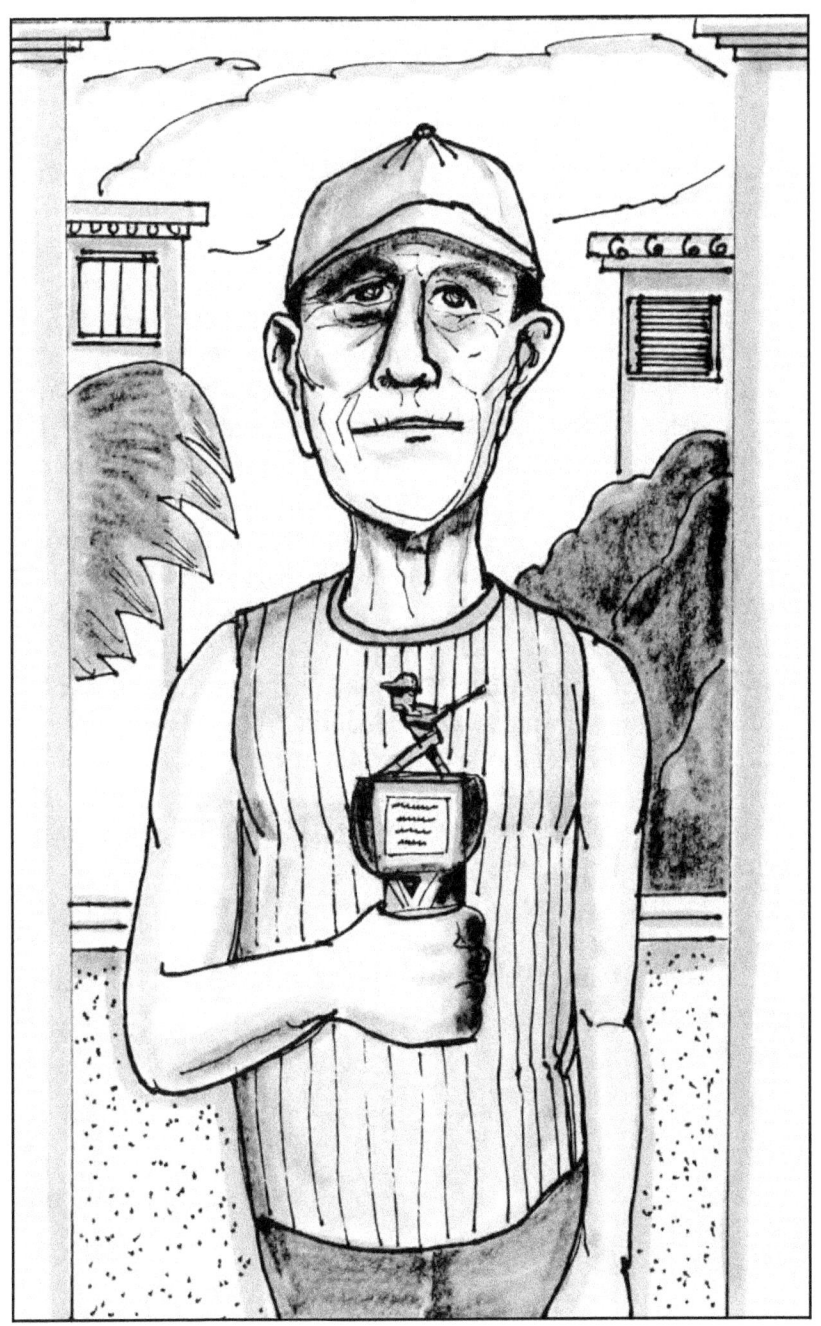

JOHN LENNON PARK
Calle 17 & 6, Vedado, Havana

Graceful trees fan out along the walkways of John Lennon park. On a central bandstand, gleaming in the sun, is the sculpture of a giant white tooth.

Not far away John Lennon's bronzed likeness is seated on an iron park bench. Cuban teeny-boppers snuggle into his lap for cell phone selfies. It's heartening to see these island children connect to the music of my generation.

When the young fans leave, an older gentleman takes off John's cheap drugstore eyeglasses. There's a hole above each bronze ear where the glass stems fit.

Apparently, the original glasses were stolen after Castro, having banned the Beatles music for decades, changed his tune and dedicated this statue in 2000 to the strains of "All You Need is Love."

The older gentleman who had removed the glasses, offers to put the specs back on John's bronze nose for a small price, if I want to take an authentic picture.

The old man restores the glasses on John with such infinite care, it feels as though I am participating in a sacred ritual. With a click, the sacrament is complete.

When I lower my lens, the man quickly slips the specs safely into a cheap pink plastic case.

Imagine. One more resilient Cuban with a brilliantly simple survival plan.

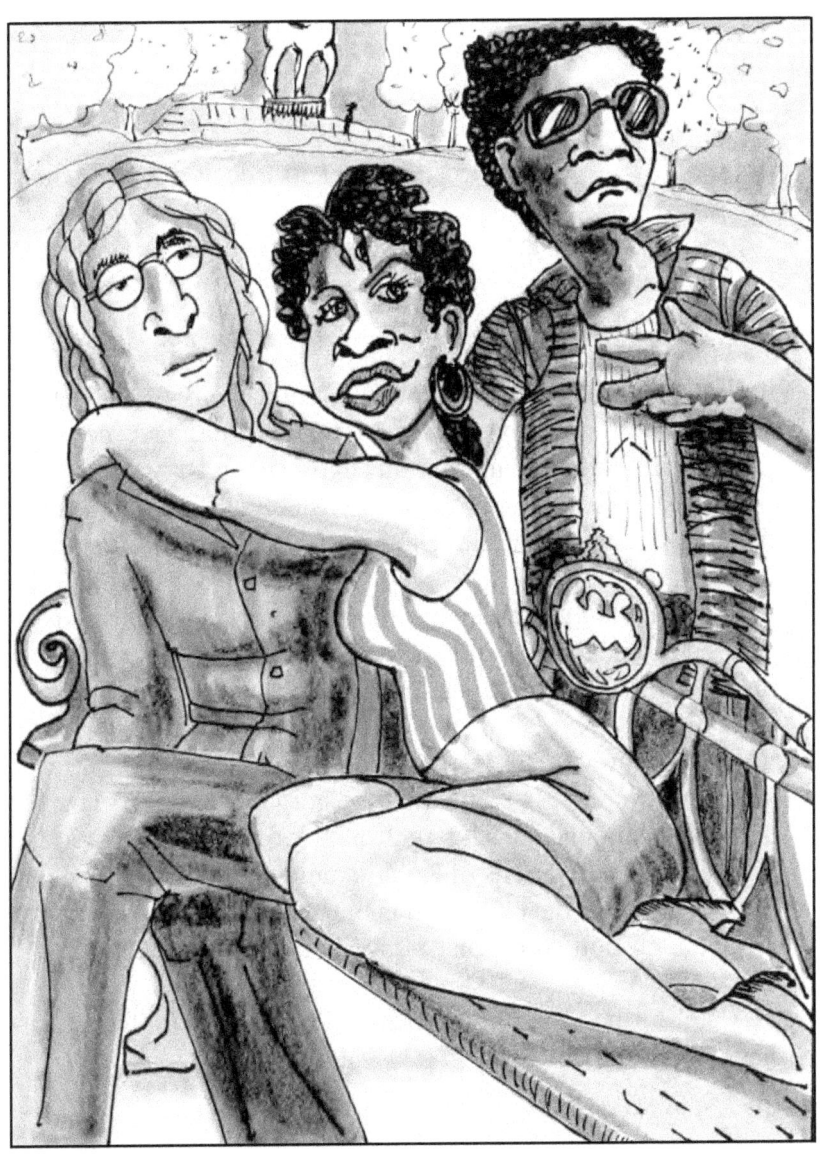

CASA DE LA AMISTAD
Calle Paseo &19, Vedado, Havana

It's too hot an evening to sit around so I decide to walk to the Amistad.

Casa de la Amistad, is a bright pink neoclassical mansion, built a century ago for Catalina, one of the most beautiful women in all of Cuba.

Trapped in a loveless marriage she ran away to Paris with the man she adored. Years later, Catalina was the first to make use of the new divorce law in Cuba. Her newly legitimized husband built her this extravagant showpiece.

Inside the mansion is a Cuban Fashion Design Show for the elite. I'm dressed in a damp shirt and shorts but I stroll in anyway.

Straight and gay couples, lavishly dressed, hold brightly colored drinks. They mingle around the outdoor runway under lighted palms, waiting for the unveiling of the collections.

The evening's hit is the Frida Kahlo Collection. Her signature eyebrow is painted on the gorgeous models. Their dresses, fashioned in silks and hand-woven materials, are high-end interpretations of Kahlo's unique indigenous style.

Applause for the collection is thunderous, but not as loud as a sudden rain storm that blows in and closes the garden show.

I bolt for home as the well-heeled Cubans sprint for their new, not vintage, BMWs.

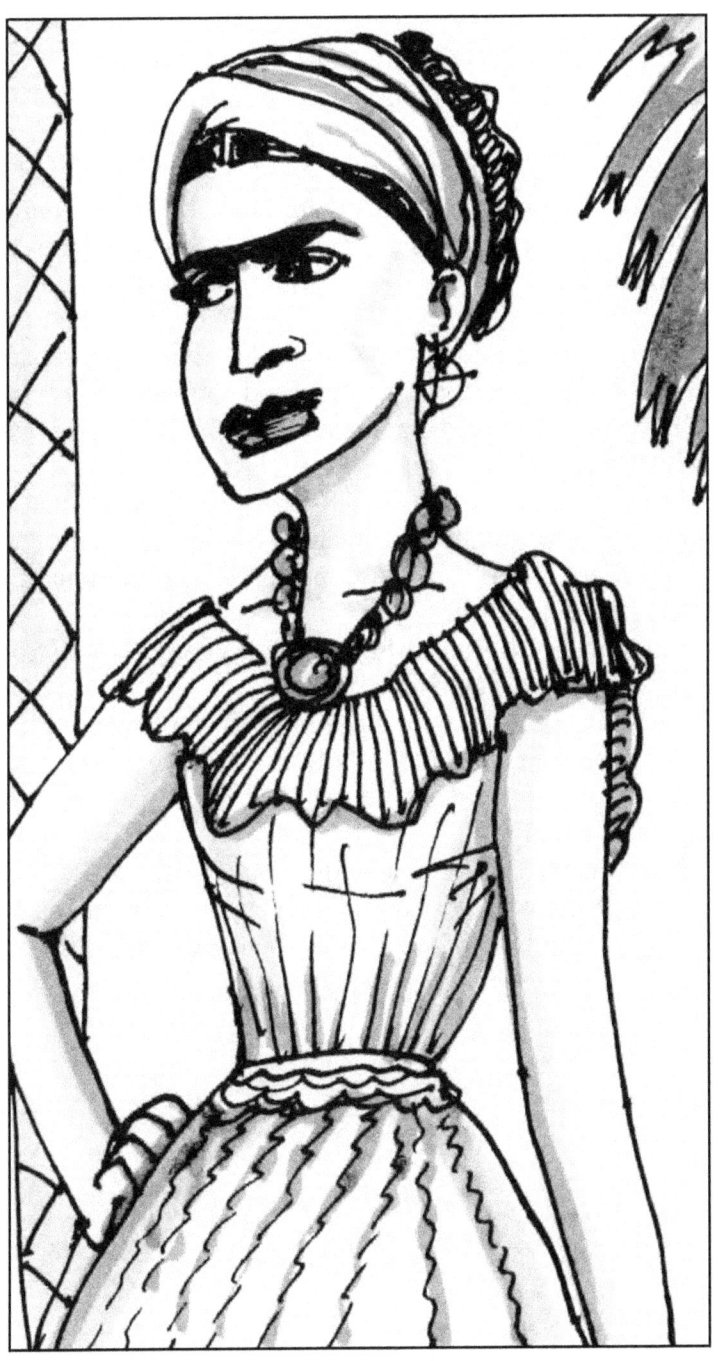

MUSEUM OF DECORATIVE ARTS
Calle 17 #502, Vedado, Havana

Another blazing hot day of exploration. Aysha and I head for a museum that we hear has air conditioning. The Museum of Decorative Arts is the neo-classical home of Countess de Revilla de Camargo, one of the wealthiest Cuban woman of the colonial era.

Each overly air-conditioned room has a different female attendant who lectures passionately and knowledgably about the particular art pieces that reflect the incredible wealth and sophistication of the ruling colonial class.

I'm amazed to see French Rococo-Louis XV furniture and a secretary desk that belonged to Marie Antoinette.

We don't stay long because the arctic air conditioning is chilling us to the bone.

In the museum's beautifully designed garden we defrost while Aysha takes a nicotine break.

I lean back in the wrought iron chair, remembering the black and white photos in the hallways of the mansion. They captured the extravagant parties that took place in this exquisite garden.

Yet when I turn and look just outside the manicured grounds to the cracked sidewalks of the neighborhood, it's clear that in nothing ever seems to change for the poor.

FINCA LA VIGÍA, ERNEST HEMINGWAY'S HOME
San Francisco de Paula, Cuba

The driveway meanders though a forested estate to the main house where Hemingway lived and wrote for twenty years. It couldn't get anymore idyllic for a writer's retreat.

Entry into his home is barred so we have to marvel through open windows. Sparse cane furnishings, subdued art and simple bookshelves render a Spartan atmosphere.

In most of the writing rooms there is a single bed, evidence of dreaming between exhaustingly simplified sentences. The most personal relic is the bathroom where Hemingway scribbled notations of his weight on the wall, keeping track for his diabetes.

He also suffered from alcoholism, depression, high blood pressure, pain from many injuries and headaches which kept him from writing.

The year he died he had been diagnosed with the disease Hemochromatosis, the inability to metabolize iron which results in physical and mental deterioration.

There was precedent for his final solution. His father, two brothers, his sister and a granddaughter committed suicide. So by the time he shot himself at the age of 61, the mystery was not why he did it, but how he had survived so long with all that plagued his mind and body.

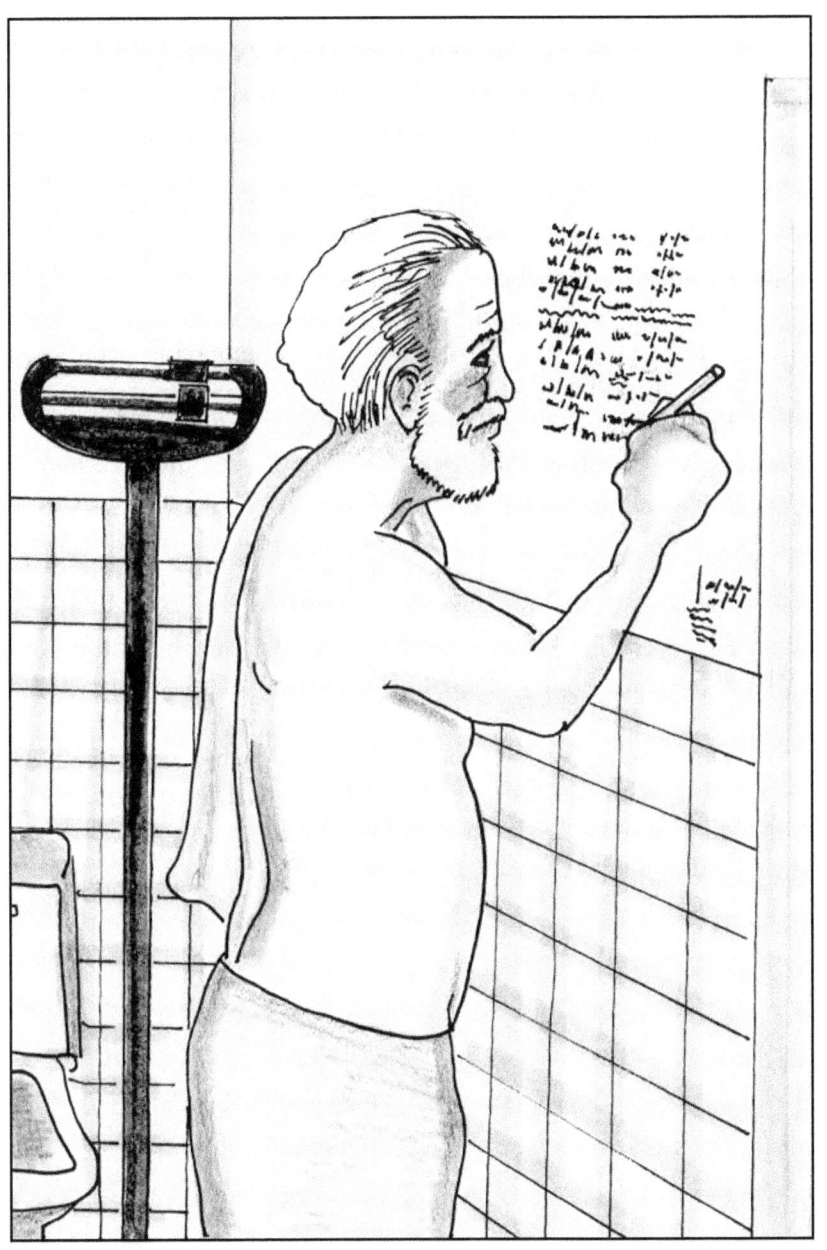

MERCADO FERIA DE ARTESANIA
ALMACENES DE SAN JOSE
Ave. del Puerto, Havana

After our morning at Hemingway's home, we have the cabbie drop us at the artisan's market, a hangar-sized warehouse at the docks. Inside are rows of the standard crafts: soaps, leathers and carvings.

What I'm looking for are the booths displaying original artwork by Cuban painters.

I follow an American voice negotiating loudly in the next aisle. It's a potbellied art dealer buying several large and astoundingly imaginative works from a local genius. I'm tempted to bring one of the smaller canvases home, but I don't have the money or the wall space.

After satiating our aesthetic appetites, we follow the smell of grilling burgers to the next dockside building. A band plays as we sit outside lunching and watching the boats go by.

This idyll gives me time to digest our richly experiential morning with the artifacts of a great writer who probably sailed past these docks in the Pilar.

Old man and the sea.

THE MALECON
Havana

The Malecon is Havana's famed esplanade where breezes cool the skin, waves smash dramatically against the seawall and ardent lovers embrace in dry spots.

I inhale the salty air and pass fishermen who cast their lines with some success.

When the tide is out, especially on the weekends, young people flock to swim, drink, play music and watch the spectacular sunsets.

The Malecon is a five-mile stretch linking the historic Havana Vieja district to the high rises in the Vedado neighborhood where I live.

The Malia Cohiba is one of tallest buildings in the Vedado with a wonderful rooftop pool/restaurant.

PLAZA DE ARMAS
Havana Vieja

Havana Vieja is the historic heart of Havana and a UNESCO site.

The main entrance is the Plaza de Armas, a spacious tree-filled square surrounded by restored Baroque facades.

I browse the book stalls and can't resist buying a black and white photo of Castro deep in conversation with Hemingway.

Three Afro-Cuban women in wild, colorful Colonial costumes surround me and persuade me to pay a few CUCs for shooting selfies with them.

As they huddle close for the photo, I inhale their gardenia perfume.

HOTEL AMBOS MUNDOS
#153 Obispo, Havana Vieja

I follow the crowd down Obispo, the liveliest pedestrian street off the main Plaza de Armas.

A block away is the Hotel Ambos Mundos, famous as the site where Hemingway wrote his novel, "For Whom the Bell Tolls."

Hemingway's old room, 511, where he lived from 1932-35, is kept as a shrine. In Cuba, anything to do with Hemingway is golden.

Inside the modern lobby of the Ambos Mundos, a piano player bangs out an old Beatles tune, "Back in the USSR."

I wait in line for the old fashioned cage elevator that looks like a rebar confessional. It creaks to the rooftop restaurant that has a great view all the way across the bay.

Mojito happy tourists raise their glasses and are in the blissful process of being well fed.

I whip out my sketchpad and order a pork sandwich, green salad and ice tea.

EL FLORIDITA BAR
#557 Obispo, Havana Vieja

After lunch, I continue down Obispo, a carnival of sound. It's filled with small shops, galleries and cafes.

Along the way I snack at Café Europa, which I can't recommend for anything other than charm and convenience.

Obispo ends at legendary pink El Floridita Bar, famous as "the cradle of the daiquiri," which Hemingway is said to have invented. When did the man have time to write?

Entering the El Floridita, for as a tourist one must, I am bombarded by a deafening band. I hold my ears and take in the scene; knots of loud happy tourists at tables, a long red bar, and leaning on the bar, a life-sized bronze statue of Hemmingway.

Uniformed waiters practically fly to deliver trays of daiquiris to the drinkers.

Patrons are obviously having a ball, but it's too loud for me. I turn and jet out, still holding my ears.

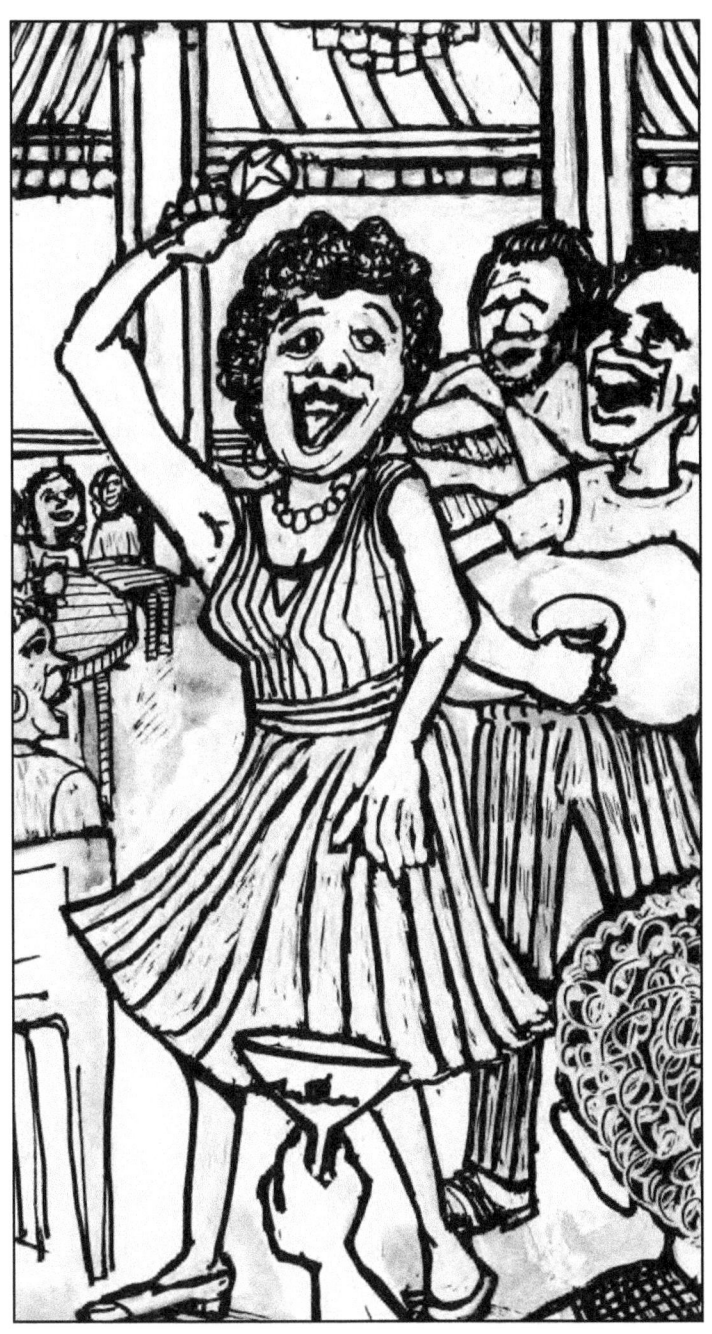

PLAZA VIEJA
Havana Vieja

Surrounded by the soft colors of the Plaza Vieja, I feel like I just landed in Venice. It's a large square with subdued yellow baroque facades, museums under tall arches, delicate arcades and Hispanic-Andalusian architecture.

In 1559, Plaza Vieja was called the New Square. In the 19th century it was re-named the Old Square. In the 50s it was a car park. Then came a beautiful job of restoration that made it into the exquisite plaza that it is today.

In the middle of the square, surrounded by all the classical architecture, is a bronze sculpture of a naked, life-sized woman in high heels seated on a giant rooster and holding a fork.

Cuban artist Roberto Fabelo created this imaginative piece. The absurdity inspires tourists to smile and flock for selfies.

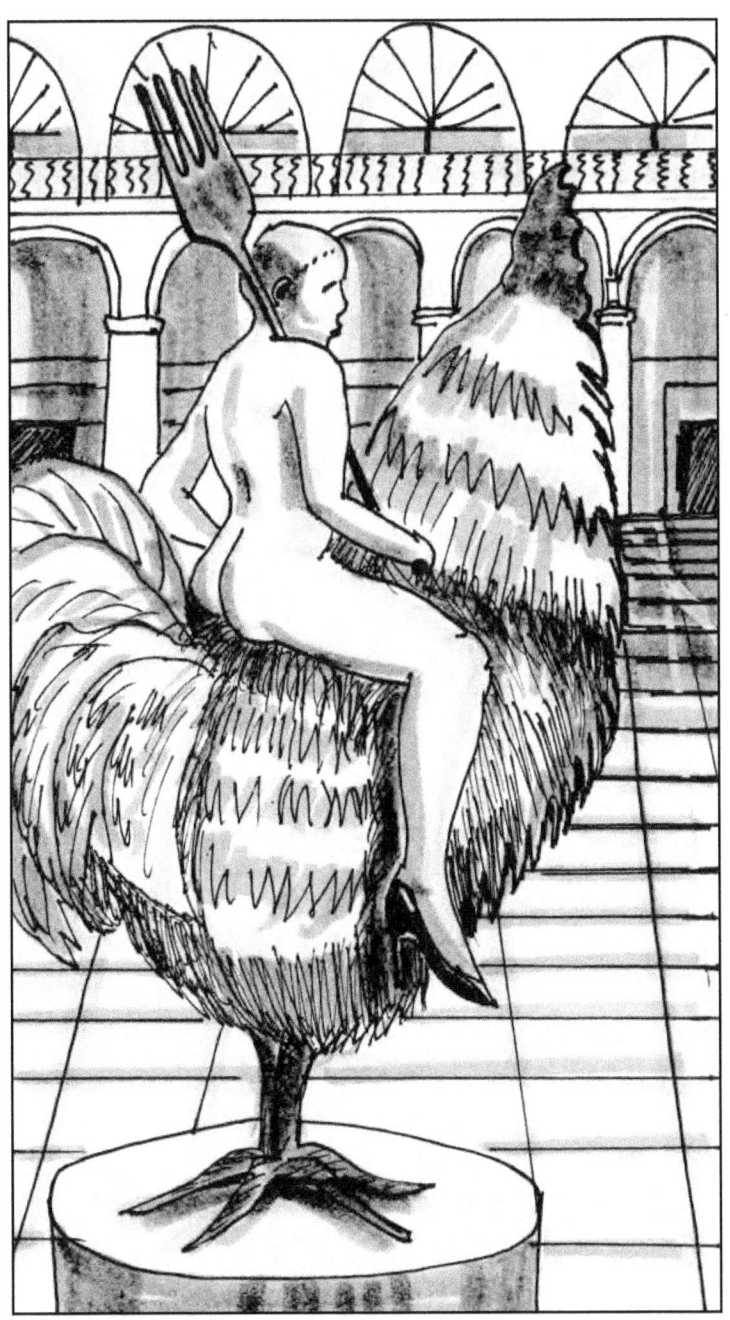

ESCORIAL CAFÉ
Plaza Vieja, Havana Vieja

On the corner of Plaza Vieja is the famous Escorial Café, known for the best fresh roasted coffee in Havana, although sometimes they run out of beans.

I sit outside under the tall pillars and inhale roasting fumes wafting from inside. My cup is just how I like it-black and strong.

The corner locale is great for people watching. Uniformed school children line up for a race across the plaza. Their whistle-blowing teacher is taking it very seriously.

French backpackers rest against the enormous columns, eat licorice and check their maps. One of them is singing a rap song in French.

A young couple wearing blue and yellow wigs, flap their arms around the rooster sculpture and take selfies.

TALLER EXPERIMENTAL DE GRÁFICA
Plaza de la Catedral, Havana Vieja

There are five large plazas in Vieja.

Plaza de la Catedral has the added attraction of housing a graphics art school. Inside the Taller Gráfica the air is cool. In the large room rows of art students work at their individual stations.

One student pulls her etching off a huge metal press and holds up the intricate results. An American couple buys the black and white print on the spot.

Another student who is from my home state of Oregon, confides that the school has only a bare minimum of supplies. Even so, the works produced are bold and excellent and on sale in a small gallery upstairs.

A half block off the square, I find La Bodeguita del Medio, (*Little-shop-in-between*) where Hemingway drank his mojitos.

The small bar has long been the watering hole of famous people including my favorites, Gabriel García Márquez and Pablo Neruda. Today it's so crowded there's no way I can get in to eat or drink.

NECROPOLIS DE COLÓN
Calle 12, Havana

It's a relatively overcast day which is a relief because my shirt is already damp.

I stand in the breezy doorway of a small church at the hub of Havana's fifty-three-acre cemetery. From here, wide lanes, lined with Banyan trees, radiate to the far corners of the Havana's largest graveyard.

I roam slowly down the lane, past exquisitely crafted sculptures. Larger than life angels and heroes on giant marble tombs seem to soar skyward. It's like wandering in an outdoor Louvre.

Farther back among lesser headstones are piles of crumbling wreaths. Hilly knolls support abstract metal sculptures.

I circumambulate a multi-sided ossuary. The interior rooms are filled with small boxes of bones piled to the ceiling with names and dates scrawled on the outside. It makes me think of books in an abandoned library.

On my way out, I pass an administrative building with Cubans waiting in yet another line, perhaps to register for a grave site.

MUSEO DE REVOLUCIÓN
*Calle Refugio 1, Monserrate & Zulueta,
Central Havana*

The day is gray which helps with the heat but not the humidity.

A low iron fence surrounds a giant glass building. Inside is the *Granma*, a large yacht, that Castro powered from Mexico to Cuba for the initially unsuccessful 1956 invasion.

The Granma was built for twelve, but eighty-two rebels crammed themselves aboard which complicated their trip to the invasion.

I don't see an entry gate. So, as any entitled American would do, I start to climb over the fence.

A grim-faced solider runs at me, pointing his automatic rifle. I hop back quickly and pray I won't hear his safety click off. Fortunately, as I land on the sidewalk, the soldier lowers his rifle and returns to his post.

Later Aysha tells me that, had I done that a few years earlier, I might have been shot.

I finally find the Museo de Revolución a block away. It's a huge, white building that was Batista's presidential palace until the 1959 revolution.

The rooms are filled with the black and white photos of strong young barbudos *(bearded men* and beautiful young women in sweaty fatigues. What heady days those must have been for the bright young doctors, lawyers and professors triumphing over the dictator Batista.

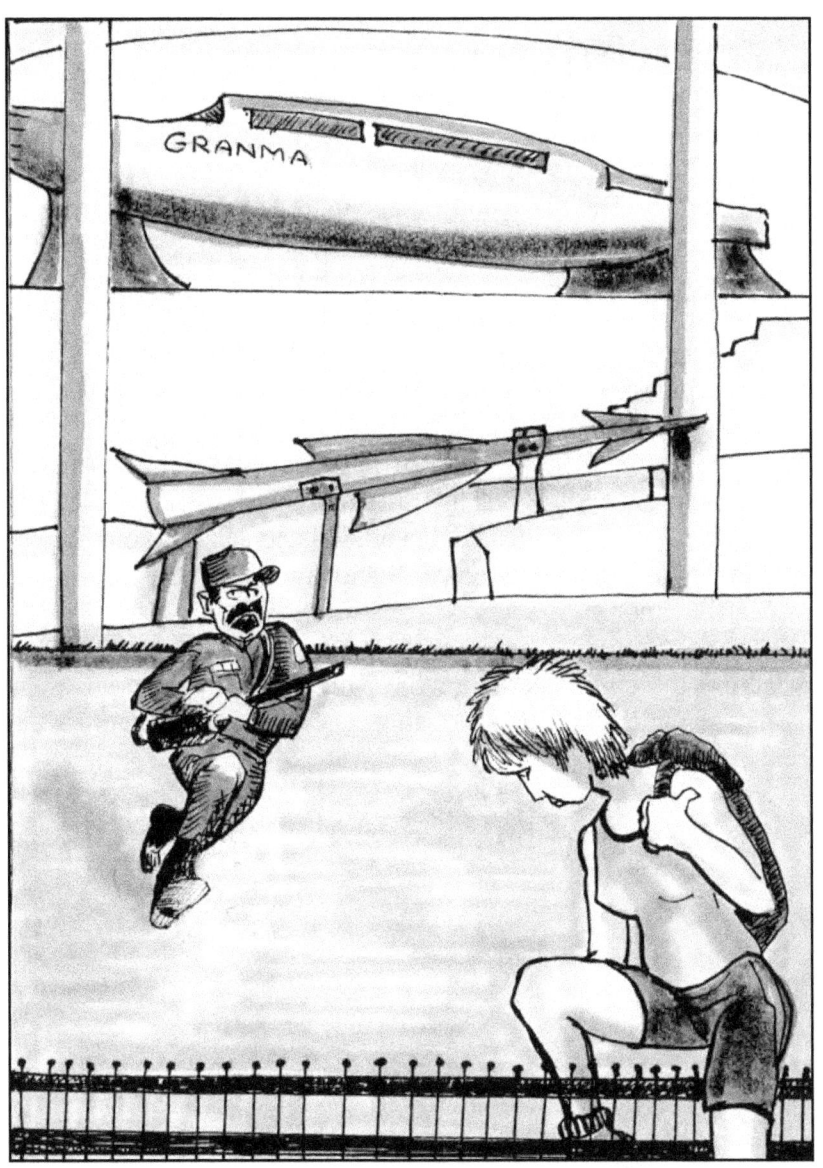

PLAZA DE REVOLUCIÓN
Havana

I get off the bus in what looks like the world's biggest parking lot. The Plaza de Revolución is a municipality and a square. It can hold a million standing Cubans and it did during Castro's many ten-hour post revolutionary speeches.

The most famous moment came during Castro's first triumphant oration when a dove landed on his shoulder. An avian emissary of peace! A roar went up from the crowd. "A sign from God!"

Since the fifties the plaza has been the political and cultural center of Havana. Buildings that border the plaza include: Museo de Postal Cubano, Palacio de la Revolución, Teatro Nacional, Biblioteca Nacional José Martí and the Martí memorial.

A bronze wire sculpture of Che Guevara's face stretches across the entire facade of the Ministerio del Interior. A plaque under it is Che's slogan, "Hasta la Victoria Siempre" (*Always strive for Victory*)

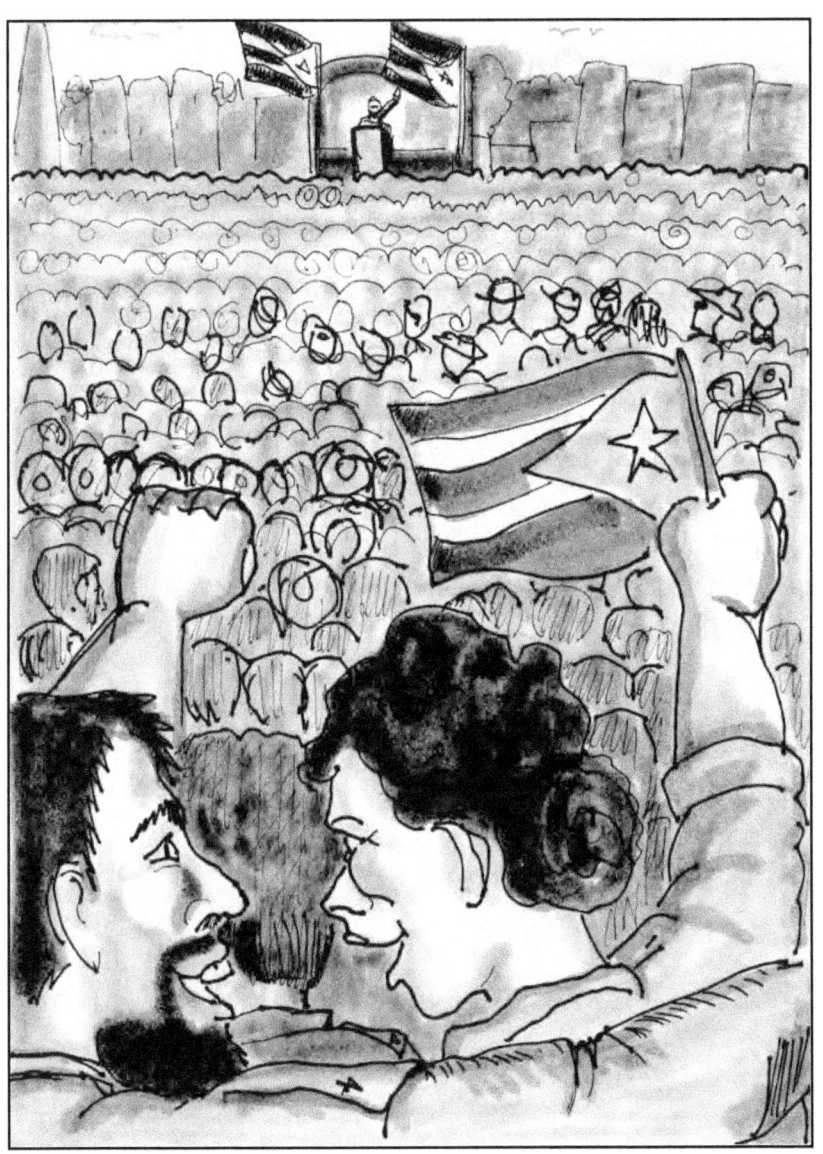

JOSÉ MARTÍ MEMORIAL
Plaza de Revolución, Havana

Casting a long shadow over Revolución Square is a three hundred foot high tower with an incredible view of Havana.

The tower and the sixty-foot marble statue in front of the tower are monuments to Cuban-born poet José Martí, the revered national hero and soul of Cuba. He's called "The Apostle of the Cuban Revolution."

There are plaster busts of him on nearly every block in the Vedado neighborhood where I live. There's even one in New York's Central Park.

Long after Martí's death in 1895, at the age of 42, a poem from his famous book, "Versos Sencillos" (*Simple Verses*) was adapted to the song "Guantanamera" which is the definitive patriotic song of Cuba. Who knew?

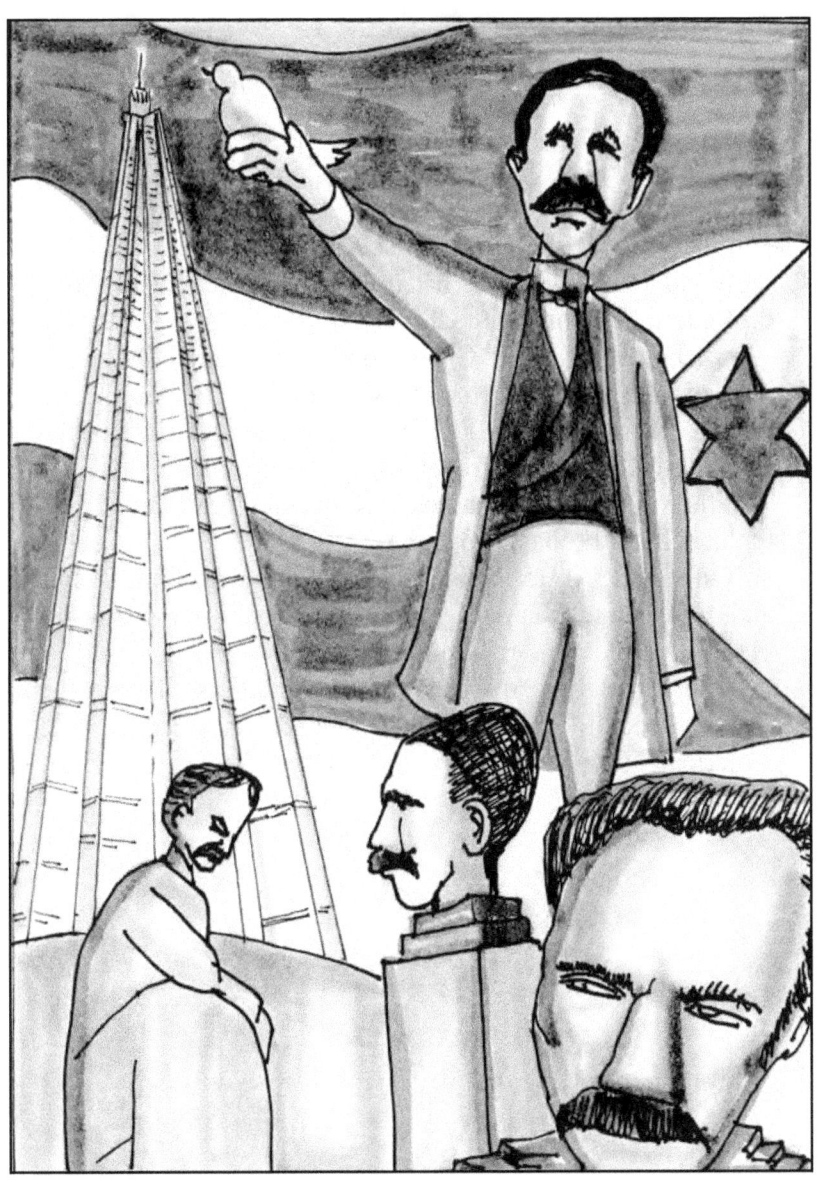

U.S. EMBASSY
Calzada between Calle L&M, Vedado, Havana

The concrete glass and cement building of the U.S. Embassy is designed in the Modernist-Brutalist style which was popular in the fifties and still feels intimidating to me.

It was January 3, 1961 when President Eisenhower broke diplomatic relations with Cuba.

On January 7, 1961 Chargé d'affaires Daniel Braddock handed the keys of the U.S. Embassy to the Swiss ambassador in Havana. The Swiss acted as protectors of the building when Castro threatened to confiscate it.

The complex was renamed U.S. Special Interests and was the unofficial Embassy in Cuba.

On July 20, 2015, Cuba and the U.S., under Raul Castro and President Obama's leadership, took steps toward restoring diplomatic relations.

The same three marines who lowered the flag in the 1961 raised the flag in 2015, and once again, the American stars and stripes fly over the official U.S. Embassy in Cuba.

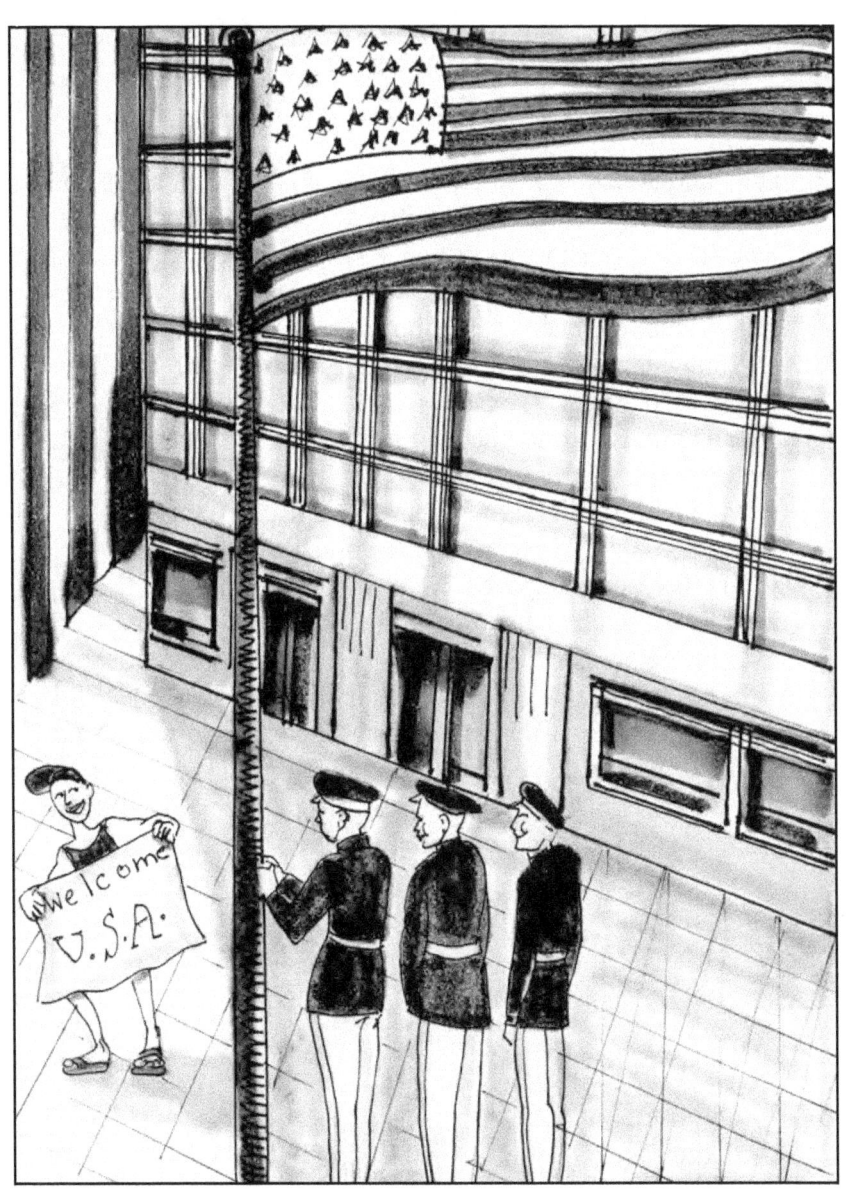

MUSEO NACIONAL DE BELLES ARTES
Calle Trocadero, Central Havana

Talk about bizarre! A two story cockroach clutches the museum wall. Alligator sculptures strain on their leashes. Near the coffee shop, a child-sized playhouse is constructed of old toasters. These Cuban art pieces show me that two things never die even in the oppressed, hope and humor.

Long ramps lead to successive galleries. The top floor houses a permanent exhibit which gives an overview of Cuban artists from the eighteenth to the twenty-first century.

My favorite painter on display is Wilfredo Lam, an Afro-Cuban, 1902-1982. His work is reminiscent of Picasso.

My favorite sculptor is Agustín Cárdenas, 1927-2001, also an Afro-Cuban, and one of the Surrealist in Paris.

A more modern painter, Julio Larraz, knocks me out with his mastery of the human figure. His powerful paintings combine simple compositions with sensuality and metaphor in ways I've never seen before.

My one complaint is the arctic air-conditioning in the gallery. It's so extreme as to induce hibernation.

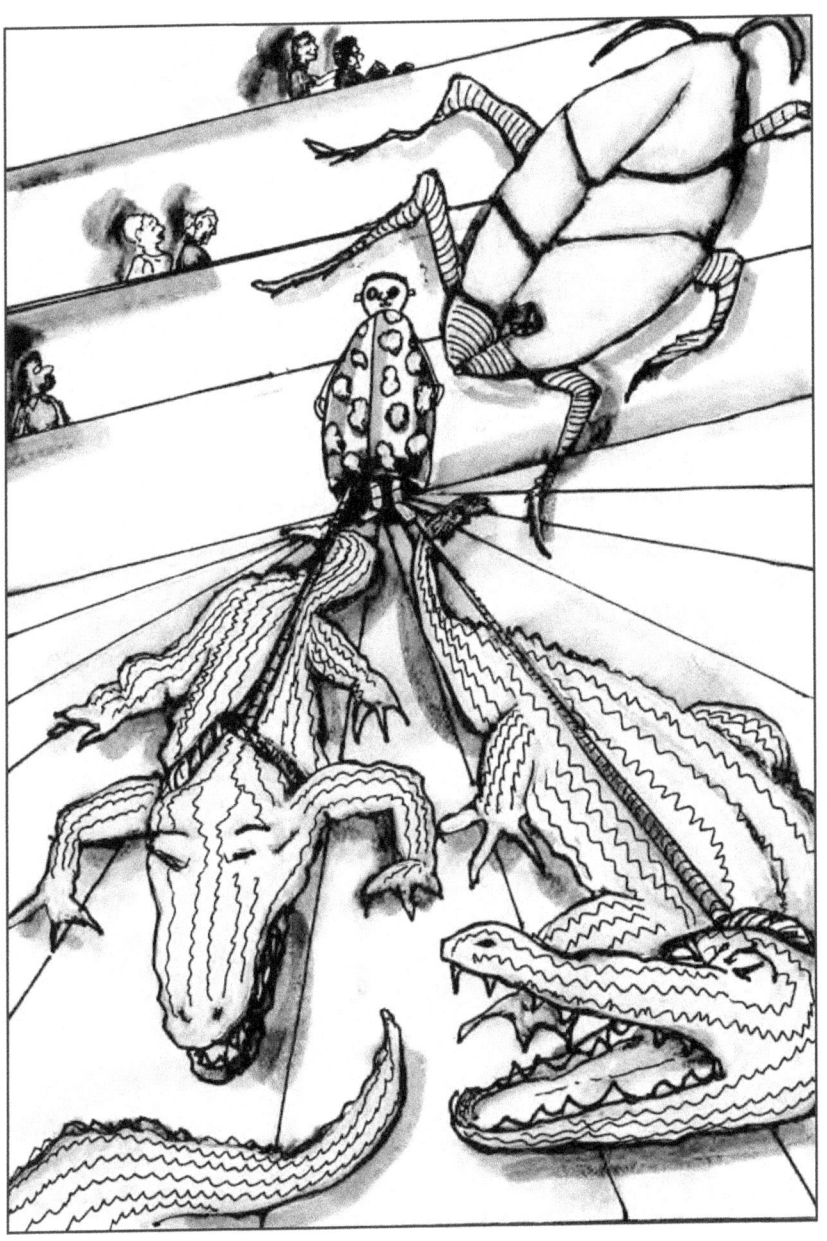

EL CAPITOLIO
Paseo de Martí, Central Havana

I do a double take when my taxi rolls past the Capitolio. It looks like the Washington D.C. Capitol building but smaller.

Not surprisingly, this was Batista's seat of government from 1929 until the 1959 revolution.

Now it is the Ministry of Science, Technology and the Environment. It has a beautiful library and an impressive gold leaf statue of the Republic that stands at the entry.

In my downtown wanderings, I also discover the famous Hotel Seville on Trocadero that Graham Greene used as a setting for his famous novel, "Our Man in Havana."

I love the book and the movie starring Alec Guinness, although the soggy pizza I order doesn't fit the genre.

My other hotel fine dining experience is Hotel Telegrafo, a lovely air-conditioned haven at Calles Prado and Neptuno.

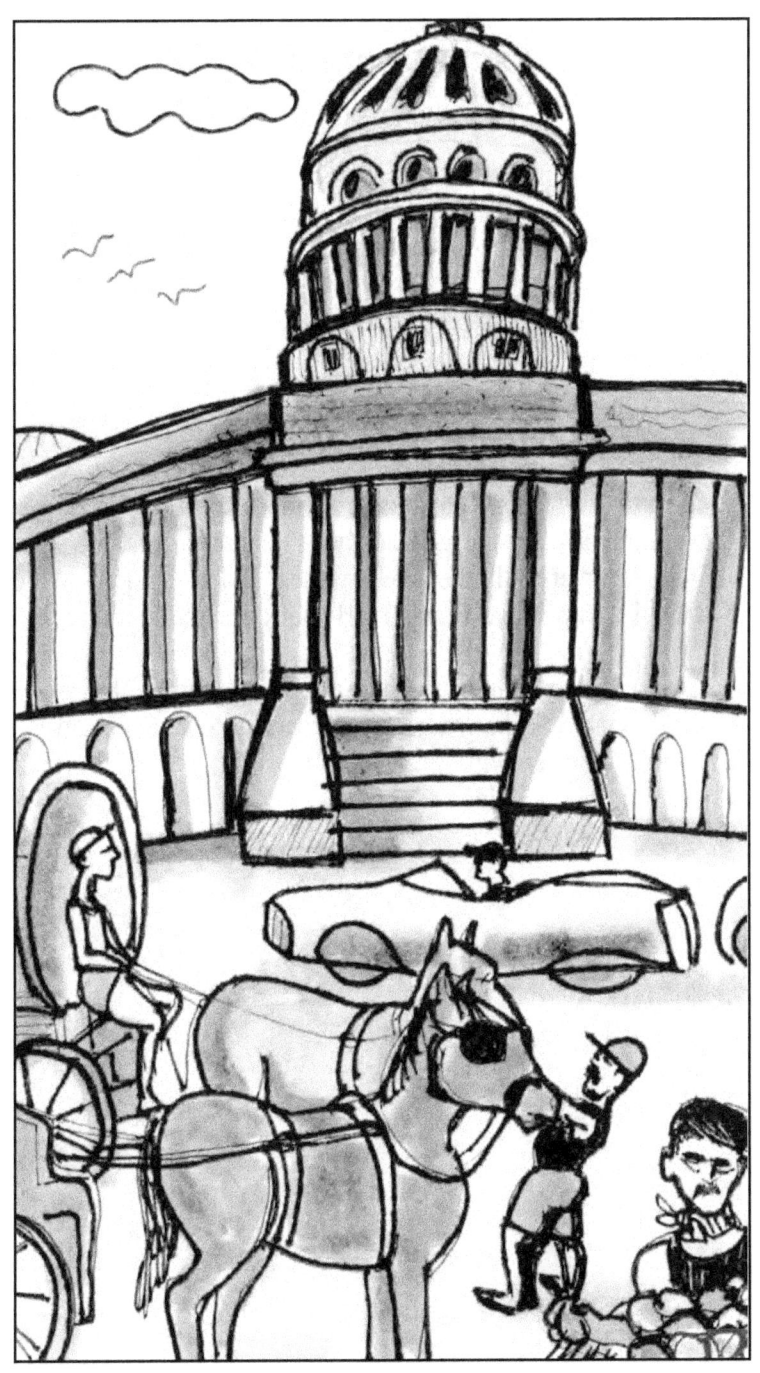

ESCUELA DE DANZIA
Paseo de Prado Street, Central Havana

Under the soaring arches of Calles Prado, I'm drawn to an elaborate doorway. Inside four beautiful adolescents dressed in ballet costumes are evenly spaced on a marble staircase. It looks like a dream.

Apparently the children are waiting to greet the Monaco Ballet Company who are performing in the Gran Teatro de La Habana that very night.

I'm enchanted and ask if I can come in to sketch. When they say no, I lean against the doorway and sketch anyway.

As a fan of classical music, I find the Gran Teatro has great acoustics for opera and other musical events.

Another venue is Teatro Amadeo Roldán, home to the National Symphony. Teatro Karl Marx draws big name rock and pop groups.

The Tropicana and the Buena Vista Social Club are two of the most popular tourist attractions. The Buena Vista Social Club musicians are not the originals, but so what? There's no bad music in Cuba.

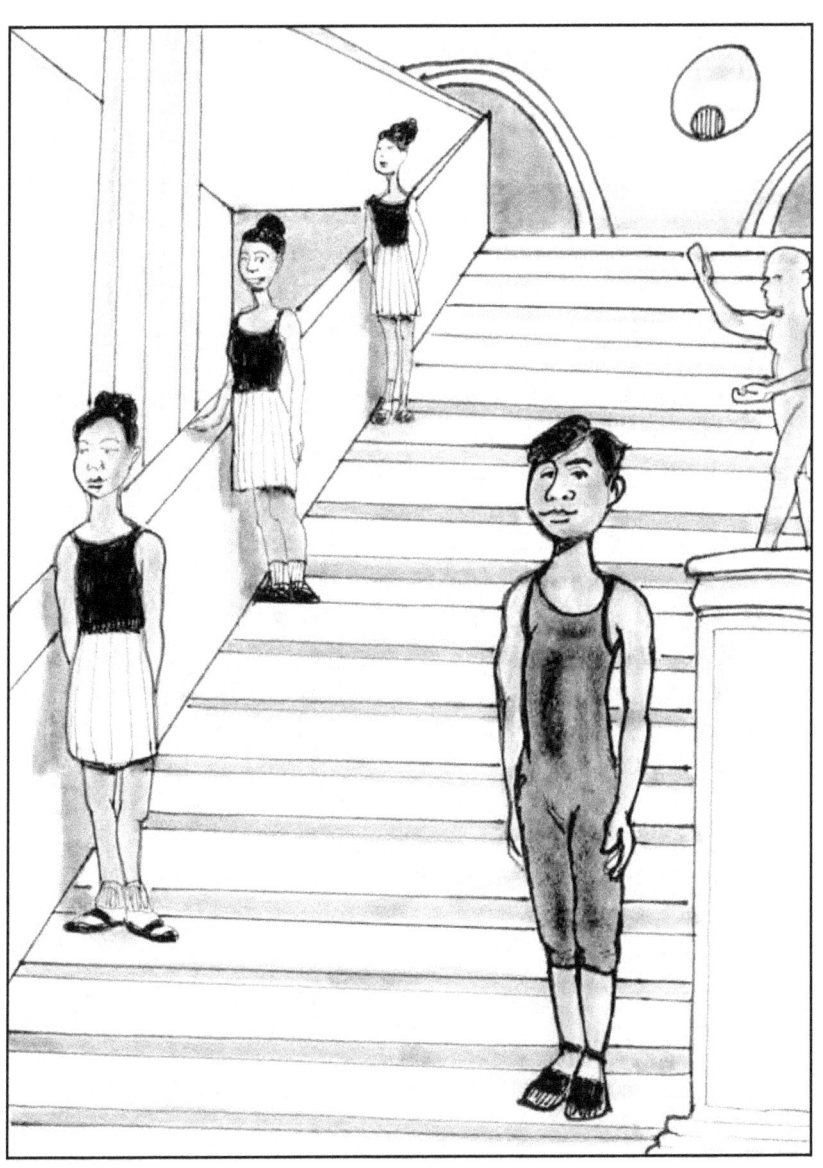

CENTRAL PARK
Paseo del Prado, Central Havana

I'm minding my own business, catching a bus in Central Park when a young newspaper vendor waves a copy of the propaganda rag, "Granma" in my face insisting I buy it.

An older gentleman sitting on a park bench raises his finger in the air. "Senora. Fear nothing. Cubans protect strangers."

He gestures for me to sit next to him. I sit quickly and the vendor retreats.

My protector wears a torn, short sleeve yellow shirt and his eyes are cataract gray.

Like most Cubans I've met, he talks loudly and with ferocious passion. He speaks like the best of lecturers on the good and evil of his country,

When I run for my bus, he surprises me by struggling to his feet and running alongside with his hand out. I give him money, of course, because I now realize the gentleman's trade is discourse. His intelligent tirade is the way he supplements his unlivable government pension. My CUCs are his next hot meal.

I hop on the bus, watching as he returns to his bench.

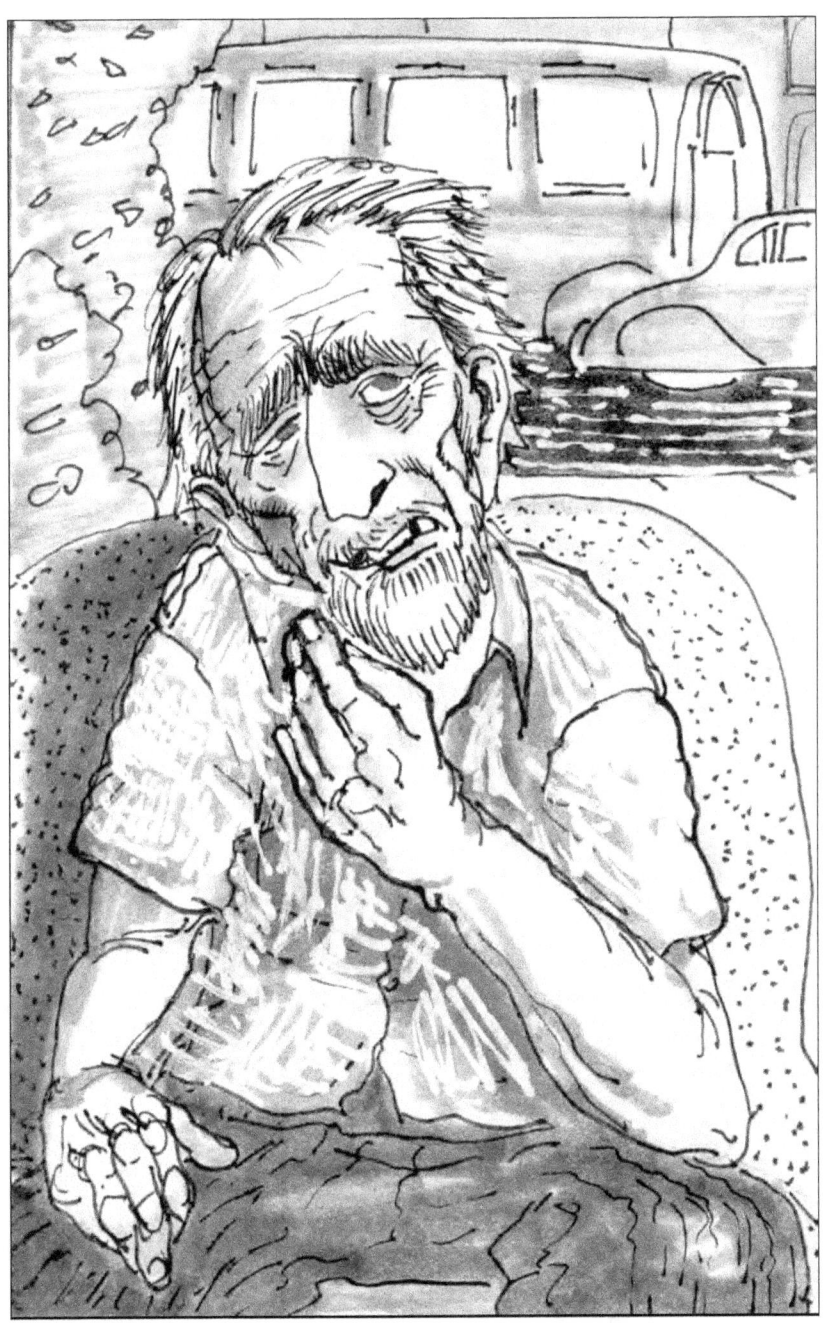

CASTILLO DEL MORRO, SAN CARLOS DE LA CABAÑA
Havana

These stone fortifications have kept the Cubans safe from marauders for centuries. Built on enormous cliffs, the stone battlements provide a vantage point from which anyone could see invading pirate ships coming from miles away.

My skin feels the vibration of history when the cannons are fired, as they are every night at 9:00, from the battlements of the La Cabaña by soldiers dressed in eighteenth century uniforms.

This reenactment is from a time when the fiery blasts let Cuban citizens know they were safe. The gates were closed and the bay was blocked by a chain.

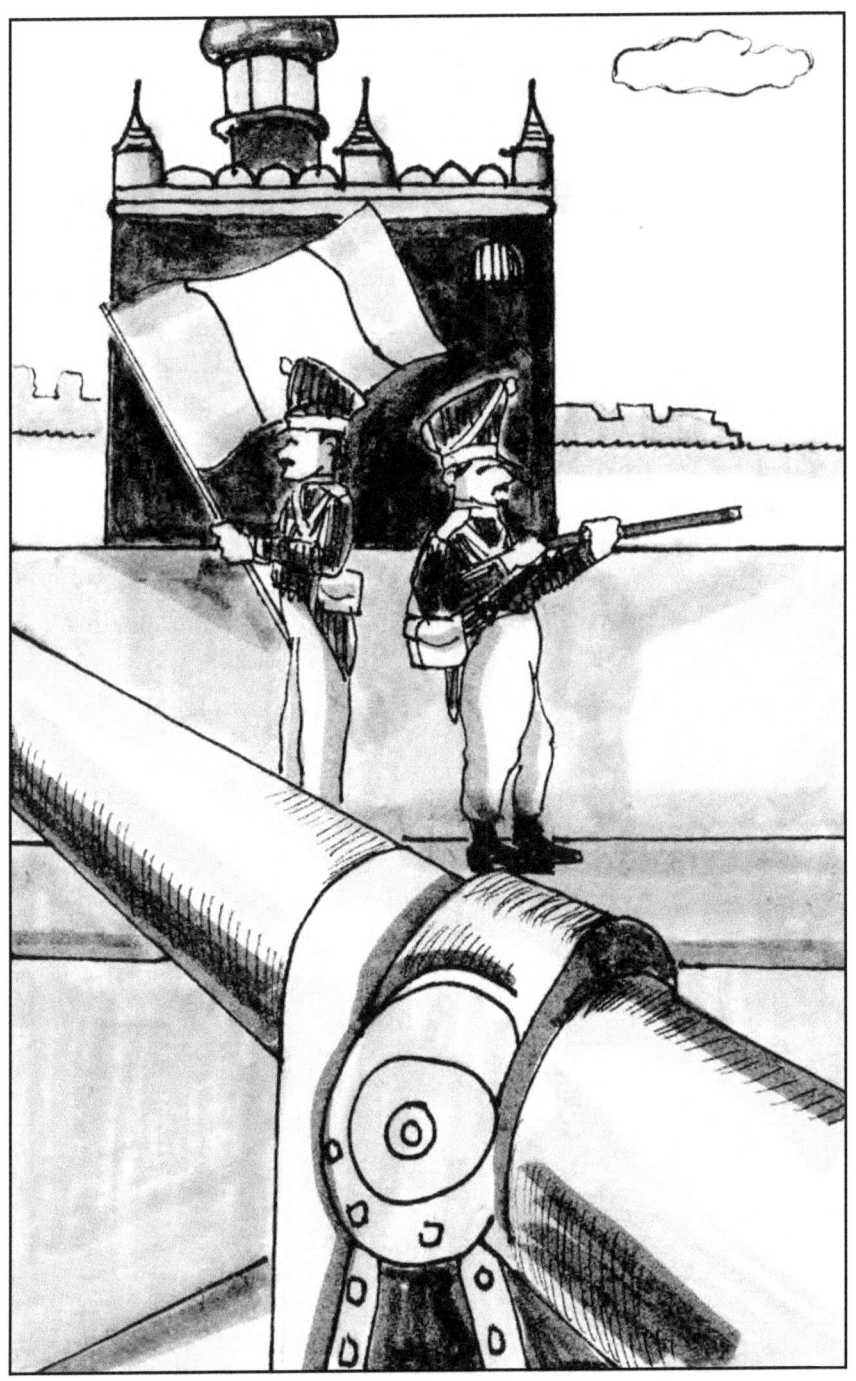

THE COLOSSAL CRISTO DE LA HAVANA
Casablanca, Havana

Casablanca is a small fishing village across the bay from the city of Havana.

This inspiring sixty-foot marble statue of Christ overlooks the city's harbor with a beautiful 180 degree view.

The statue was commissioned by dictator Batista's wife, Marta, as payback. She promised God she would finance the statue if her husband survived the tumultuous rebellion led by Castro in 1957. Batista's government did survive, barely.

The statue was completed by sculptress, Jilma Madera one week prior to the 1959 victorious revolution over Batista. To his credit, Castro left the majestic statue standing.

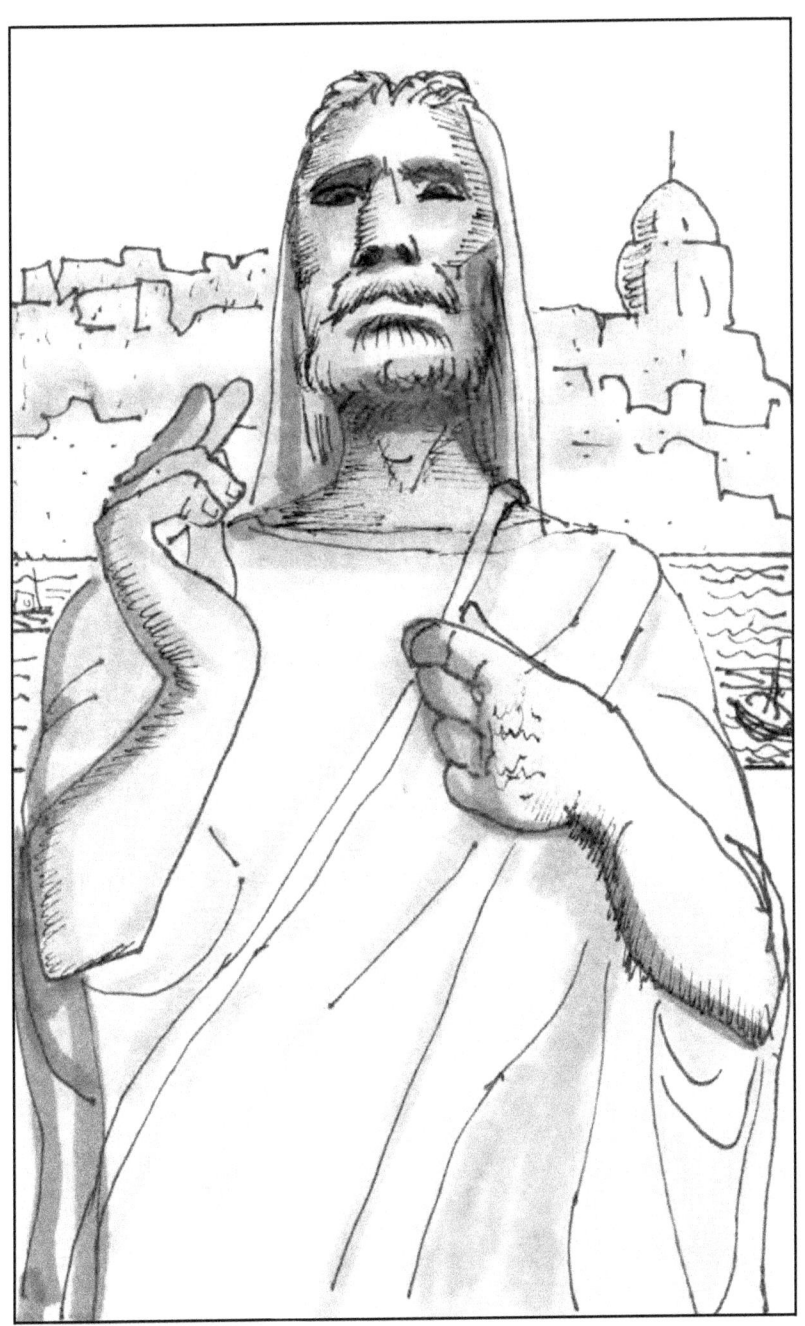

CALLEJÓN DE HAMEL
Havana

A sexy and very sweet transvestite gives me a tour through the Callejón de Hamel street, (basically an alley named after a wealthy French-German arms dealer who lived there. It's barely 200 meters long, but it attracts hundreds of tourists because of the colorful street murals and wild sculptures created by Salvador Gonzales Escalona.

As a self-taught artist living on Hamel Street, Salvador began painting murals on his neighbors walls in the 90's.

He is still adding images to three story high apartment buildings. Salvador's work is part Surrealism, part Cubism mixed with a little art-naïve.

Tourists fill the tiny coffee shop, small art gallery and colorful canopied area where, every Sunday, Santería priests dance rhumba to evoke the spirits of the Orishas.

On the way out, I notice a gray bearded man sitting on a painted bench, with one bare foot in the lap of a young girl. She's giving him a very public pedicure. He seems unruffled by tourists staring and ignores us with a pleasant proprietary air.

My friend tells me the bearded man is the famous artist, Salvador Gonzales Escalona. And, in a sense, this is his front room.

FUSTERLANDIA
Jaimanitas, Cuba

José Fuster's installations remind me of Watts Towers in Los Angeles. Fuster is a well-known Cuban artist, painter, sculptor with his most famous contribution being the public art in his home town, the fishing village of Jaimanitas outside of Havana.

In the last ten years Fuster has decorated over 80 of his neighbors' homes so that the small town itself has become a unique work of art. It is reminiscent of Hamel Street in Havana but on a much grander scale.

I follow children running through his shinning archways and past giant tiled figures. All surfaces are covered in bold murals and decorative design. It's truly amazing.

Fuster involves himself in his community and sponsors a theater and public swimming pools through the sale of his prolific paintings and ceramics.

He is constantly creating, and says, "I keep working every day to do something more spectacular."

BICI TAXI
Havana

The Bici Taxi is like a rickshaw with a bike in front. I feel guilty that this man is pedaling through heat and polluting traffic to take me to my destination.

He rings the bike bell and wipes sweat off his face with a rag. I can't imagine what his lungs look like.

Next time I'm going to take a less exploitive mode of transport like the coco taxi, a bright yellow 3-seater scooter in the shape of a big C, or even the horse drawn carriage.

The Havana Bus Tour is a great way to explore, but on top of the double-decker it's boiling when the sun is full.

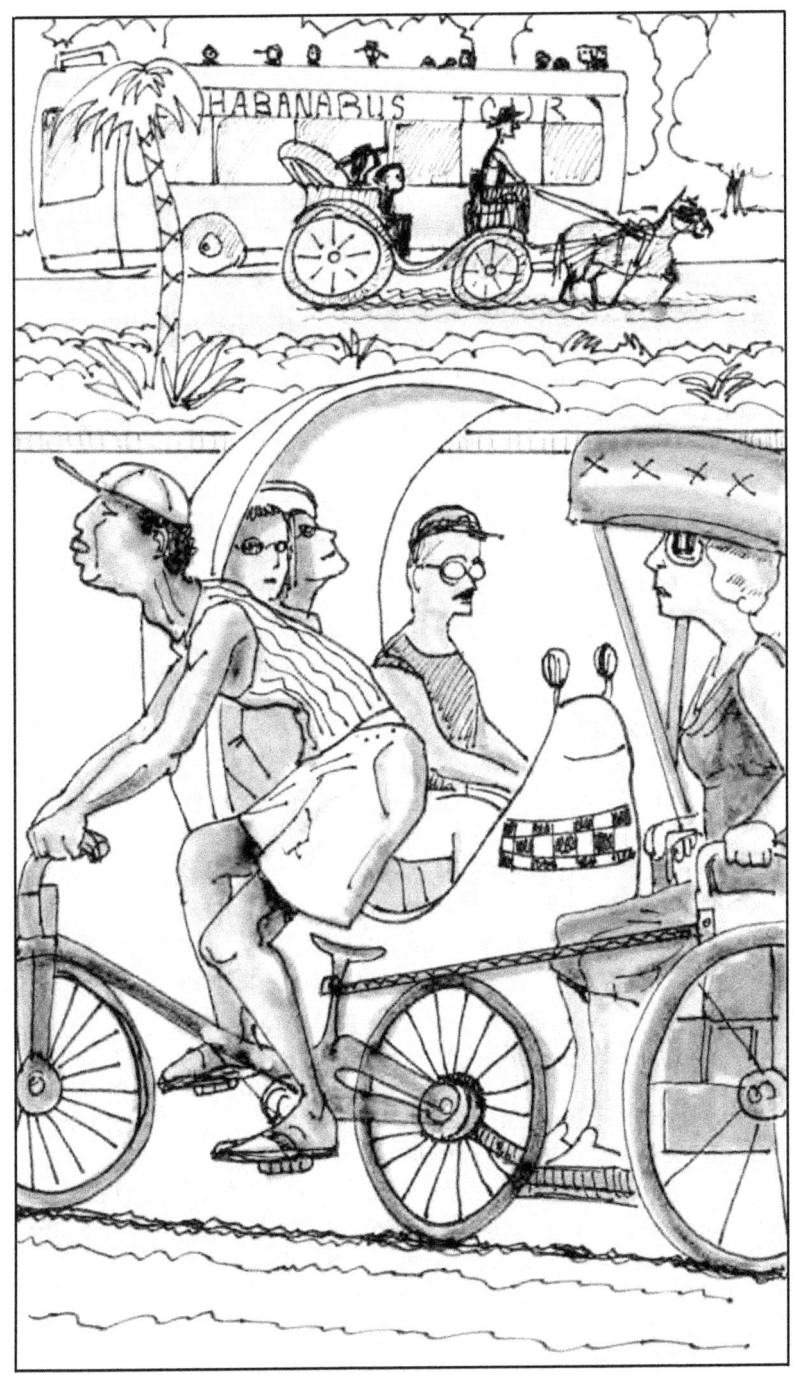

JEWS IN CUBA
Havana

As a Jew, I'm excited to discover Jewish temples in Havana. Near our hotel is the Centro Hebreo Sefaradi de Cuba at Calle 17 & E. Not only is there a place to pray but they have a museum, dining area and gym.

Even larger and more spectacular is the Temple Beth-Shalom or Patronato Synogogue, at Calle I &13.

On the wall is a color photograph of Fidel Castro sitting with the Jewish elders. All of them are wearing the traditional caps or yarmulkes.

"Has Fidel converted?" I joke to the woman conducting the temple tour. She smiles and gives me the quick story of Jews in Cuba.

In 1924 about 25,000 Jews immigrated to Cuba and prospered. After the 1959 Revolution, Castro shut down all religions and houses of worship. Cuban Jews read the handwriting on the wall and immigrated to Israel and the United States. After the Six-Day War, Castro severed relations with Israel and provided training for the PLO. More Jews immigrated out of Cuba even though in the 80s Castro mellowed toward Israel.

In the 90's, Castro was forced to return religion to the people because that was all he had to offer during the hard times after Russia pulled out of Cuba. And that also explains the cozy photograph of Fidel and the Jewish elders.

Today about 1500 Jews remain. To sustain community rituals, a rabbi flies in from Chile several times a year. The Temples are supported by contributions from Jews around the world including Steven Spielberg.

The big plus about being Jewish in Cuba, according to sources- there is no anti-Semitism. in the country.

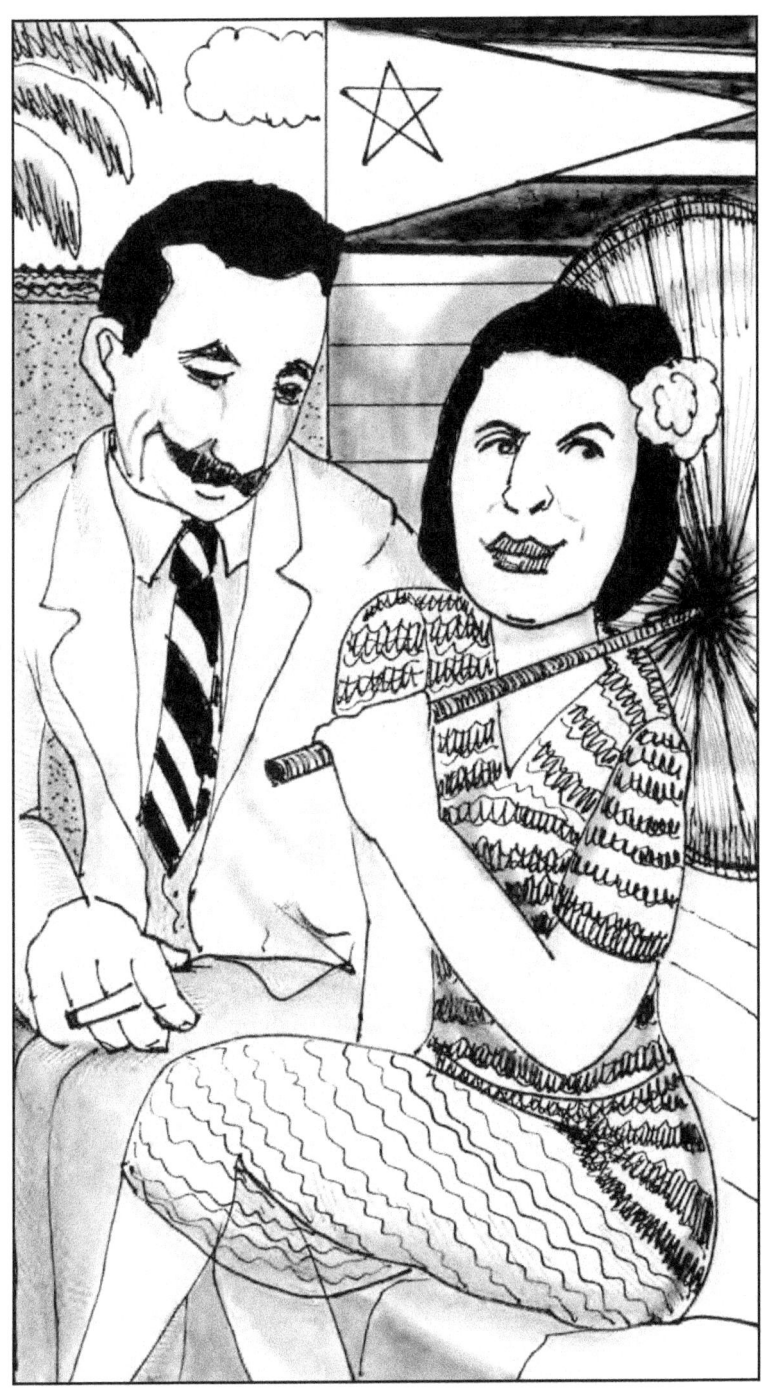

THE CHRISTENING
Havana

Dressed in our travelers' finest, Aysha and I enter a large modern Catholic church. Today is the christening of her godson, Enzo Enrique, from her adopted Afro-Cuban family. Aysha and I are welcomed with kisses and a big smile from little Enzo.

Like many Afro-Cubans, the family adheres to Catholic traditions along with their clandestine religious affiliation with the popular Santería. (*Worship of the Saints.*)

Santaría grew out of the repressive 18th century when the Yoruba from Nigeria and Benin were imported to Cuba as slaves. Their African gods fused with Spanish Catholic traditions which made for a uniquely Cuban religion.

After the christening, we party at Enzo's home, a small, dark concrete apartment that the family shares. They prepare food in a tiny half-kitchen. We take our food and beers into the narrow garden out front, sit on rusted chairs and relax in the warm, still air.

Jokes, gossip and loud laughter fill the evening as the newly christened Enzo is passed from parent to grandparent to aunt and uncle and finally to his godmother, Aysha.

In spite of their rock bottom poverty, with a generous gesture as we depart, one auntie slips a green plastic bracelet on my wrist, kisses my cheek, and whispers, "Now you are family."

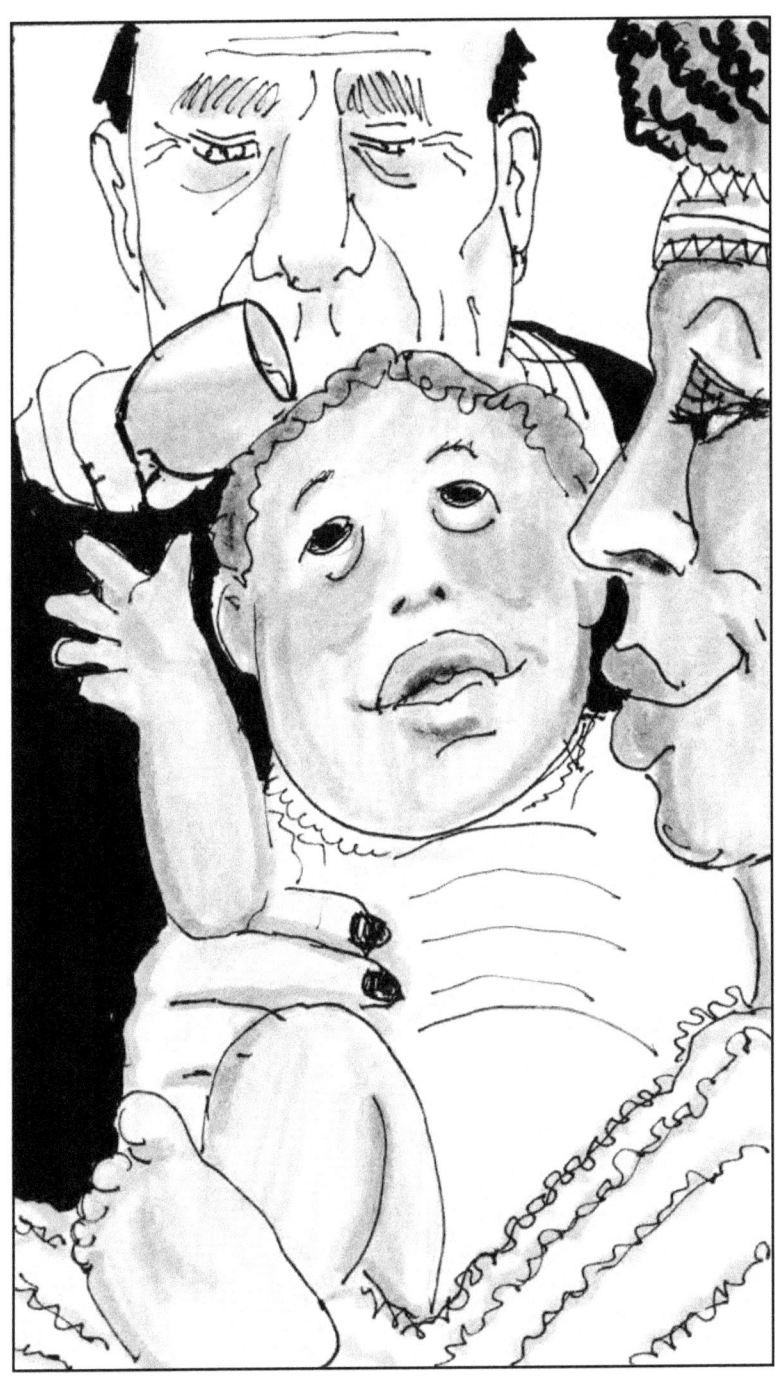

LOOKING BACK

Cubans lead their lives with an enthusiasm and passion that belies the country's condition and the dynasty's fierce hold on power at all cost.

I admire the incredible talent and perseverance of the Cuban writers, and the generosity of the two families I got to know. The everyday struggle was an eye-opener for me, never having lived in a Communist country.

I return home with a clearer picture of how important it is for the U.S to be involved with Cuba. We have much to learn from these industrious and warm-hearted people.

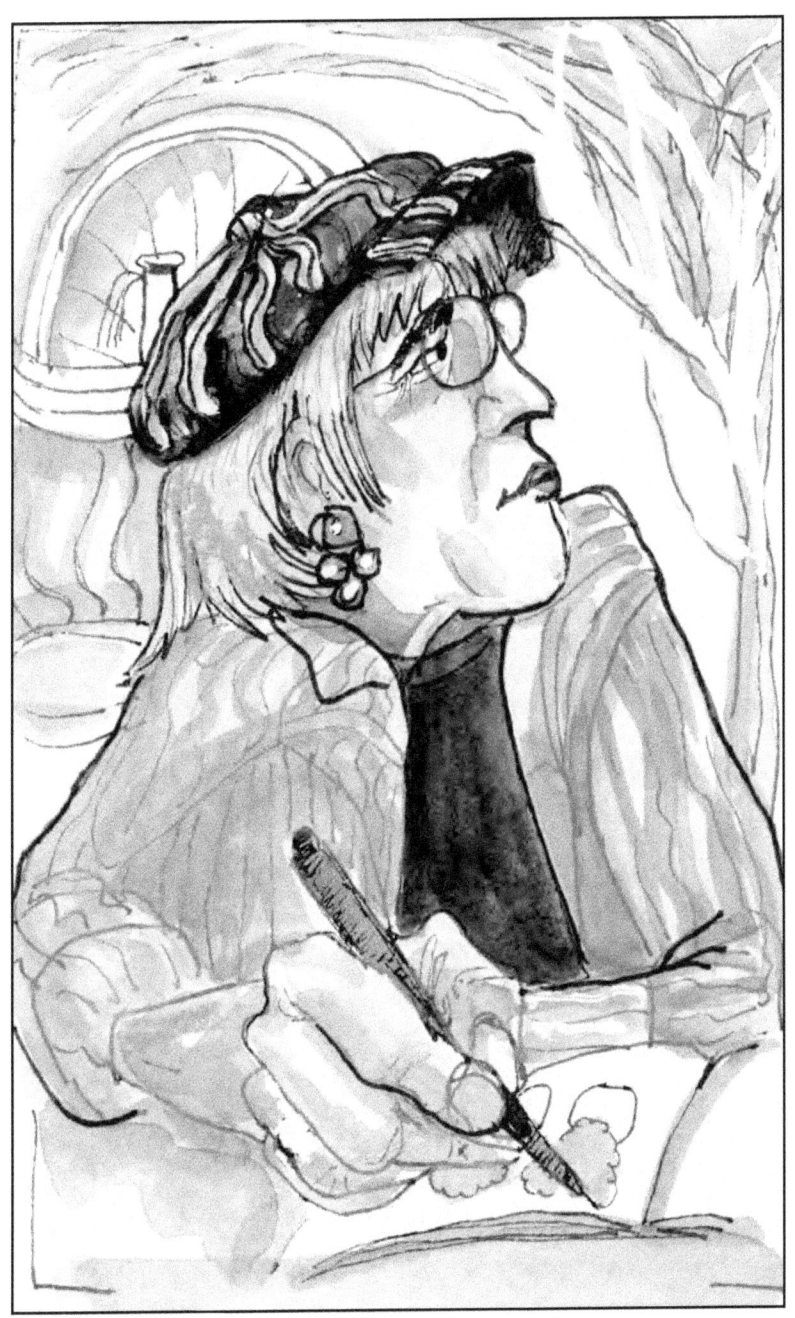

www.ingramcontent.com/pod-product-compliance
Lightning Source LLC
Chambersburg PA
CBHW070259190526
45169CB00001B/479